Secrets of
Digital
Animation

A master class in innovative tools and techniques

STEVEN WITHROW

A RotoVision Book

Published and distributed by RotoVision SA
Route Suisse 9
CH-1295 Mies
Switzerland

RotoVision SA
Sales and Editorial Office
Sheridan House, 114 Western Road
Hove BN3 1DD, UK

Tel: +44 (0)1273 72 72 68
Fax: +44 (0)1273 72 72 69
www.rotovision.com

10 9 8 7 6 5 4 3 2 1

ISBN: 978-2-88893-014-3

Art Direction: Tony Seddon
Design: compoundEye

Reprographics in Singapore by ProVision Pte.
Tel: +65 6334 7720
Fax: +65 6334 7721

Printing and binding in Singapore by
Star Standard Industries (Pte) Ltd.

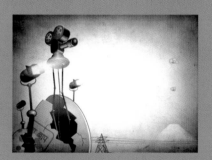

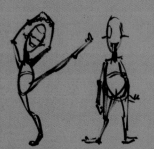

Contents

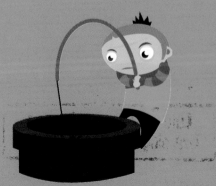
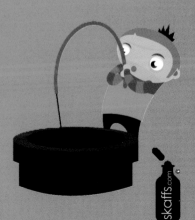

Introduction

Now's the time

To be an animation artist today is to inherit the tools and collective knowledge of the past 100 years and more. It is to adopt a venerable history and adapt oneself to an interconnected, *global* culture of competition and collaboration. Together, we are witnessing a profound shift in how animated films are made, shared, and viewed. Each in our own way, we are reinventing what animation is and whom it is for.

No matter what areas of animation interest you the most, you have arrived at the perfect time. There has never been such a wide range of options for education, specialization, and entrepreneurial vision.

To get started, you won't need a barrel of money (though it never hurts), and you don't even need to know how to draw (though it often helps). What you need is the desire to create something of your own, and the willingness to learn and to experiment—to try and fail, and to try again and again. That's all there is to it.

1

2

3

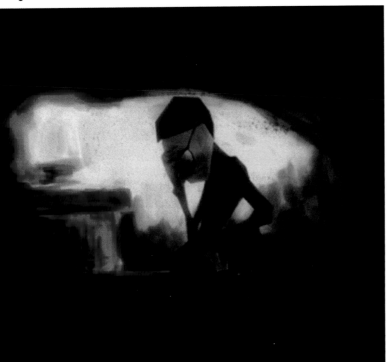

1–3. Stills from the short Solution (2006) from Hong Kong, directed by Steven Yeun and animated by Henri Wong (parabucks.com). *© 2008 Steven Yeun and Henri Wong*

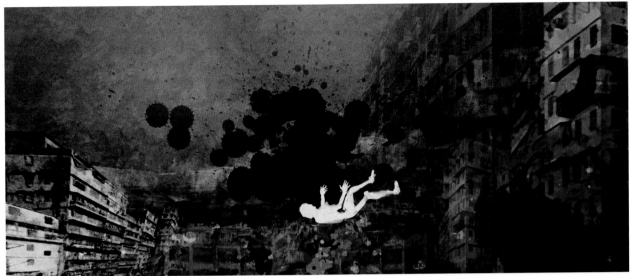

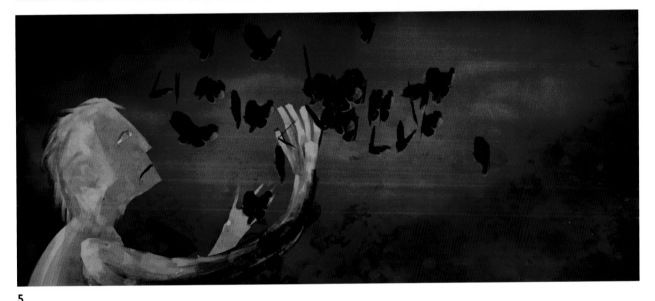

5

Why this book?

There are many technical guides about individual aspects of animation, from manipulating 3D software to timing action and dialogue, but unless the reader has already settled on a particular technique, or acquired a relatively wide skill set, there are precious few books that offer an in-depth introduction to the whole gamut of what is now possible, and a taste of some of the most important techniques around the world.

Secrets of Digital Animation offers a show-case of cutting-edge animation work along with newly influential and iconic designs within all forms of animation, from **vector** to **stop-motion**, from animated **shorts** to **machinima**, together with the inside, professional view on their creation and inspiration.

This book provides professional animators, animation students, designers, and illustrators—and fans and aficionados of each animation style—with a privileged insight into the work of some of the leading independent animators, together with stunning examples of finished work and conceptual work in progress.

It also contains practical workshops and case studies that explore the professional techniques behind designing innovative characters and bringing them to life, process by process, and inspiration by inspiration.

Get ready for an enjoyable ride through a wonderful worldwide art form!

4 and 5. Stills from the opening to the Hong Kong film *Run PaPa Run* (2008), animated by Henri Wong. © *2008 Emperor Multimedia Group (EMG)*

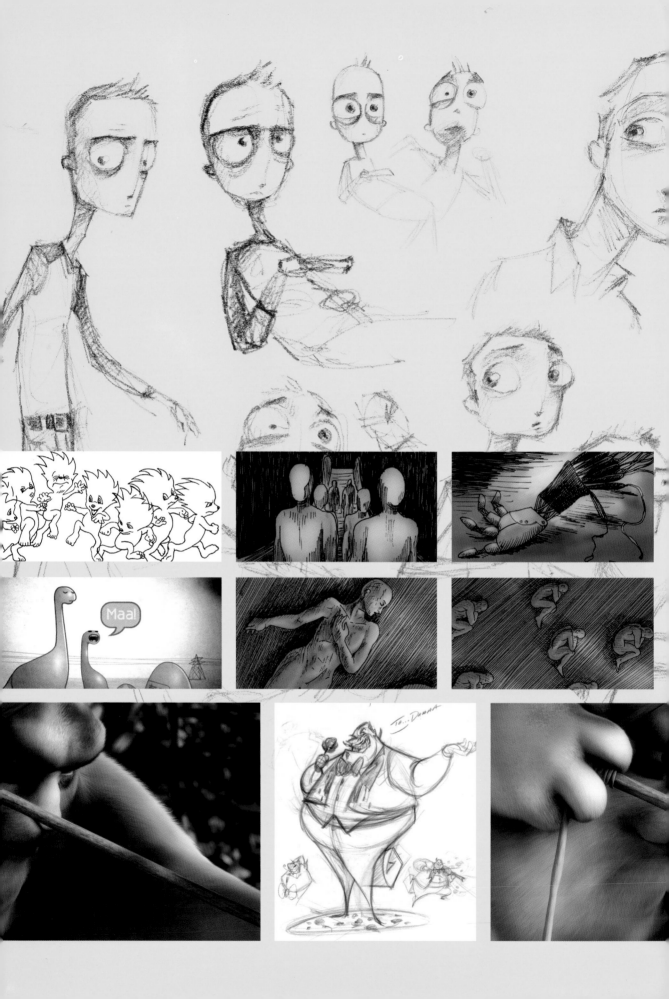

Secrets of
Digital
Animation

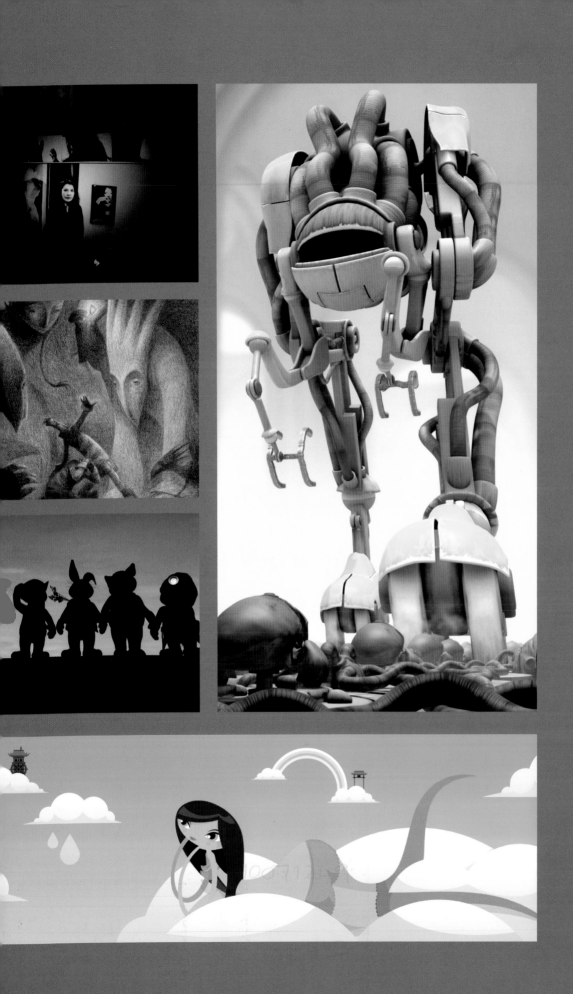

1 The Basics

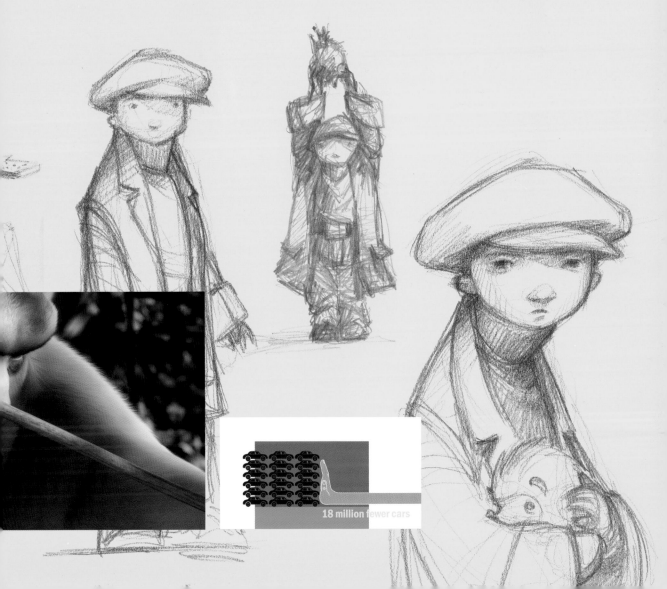

Animation essentials

What is animation?

Animation is the art of "breathing life" into still pictures. More specifically, it is the rapid display of a sequence of images to create the optical illusion of motion due to the phenomenon of persistence of vision. Animation has been around in various forms for centuries—from the magic lantern to the kinetoscope—but solidified in the early twentieth century with the pioneering work of Winsor McCay, Georges Méliès, J. Stuart Blackton, Émile Cohl, and Otto Messmer, among others.

Today, around the world, animation is both a thriving and a rapidly evolving art form that encompasses everything from simple flip books to motion-picture films and computer games. Animations can be either "full" or "limited," that is, with or without sound, music, and interactivity, and an incredibly wide array of techniques and hybrids/subsets of techniques exists, including, but not limited to:

- ❄ **2D**, traditional or **cel**;
- ❄ cutout and collage;
- ❄ **motion graphics**;
- ❄ stop-motion;
- ❄ 2D digital **bitmap**;
- ❄ 2D digital **vector**; and
- ❄ **3D** digital.

Character animation

To most people, **animation** means viewing a character in purposeful motion, usually accompanied by voice acting, as part of a larger production. Such animation invests its "actors" with thoughts and emotions in addition to physical action, making the illusion of life even stronger, and audience identification more immediate. Character animators can be brilliant, though unseen, performers; teamed with other specialists, such as writers, directors, background artists, voice actors, programmers, composers, and sound engineers, they have created some of the most revered work in the history of art.

Effects animation

Complementing character animation is special-effects animation, which creates anything in motion that is not a character—most commonly, vehicles, machinery, and natural phenomena such as plants, water, or weather. Effects animation, along with **motion capture**, has become an essential component of much live-action filmmaking, particularly in the action-adventure and fantasy genres.

JUMP

1

3

2

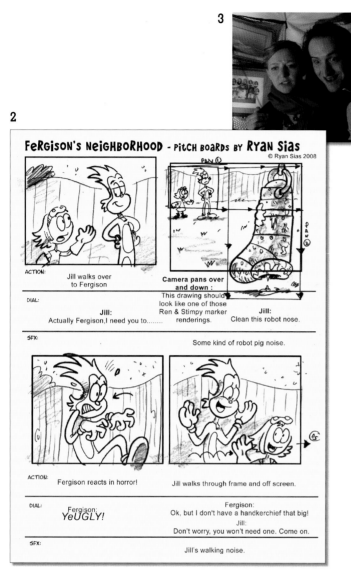

FeRGiSON's NeiGHBORHOOD - PiTCH BoaRDs By RYaN SiaS
© Ryan Sias 2008

PAN ①

ACTION:
Jill walks over to Fergison

Camera pans over and down :
This drawing should look like one of those Ren & Stimpy marker renderings.

DIAL:

Jill:
Actually Fergison,I need you to........

Jill:
Clean this robot nose.

SFX:
Some kind of robot pig noise.

ACTION:
Fergison reacts in horror!

Jill walks through frame and off screen.

DIAL:
Fergison:
YeUGLY!

Fergison:
Ok, but I don't have a handkerchief that big!
Jill:
Don't worry, you won't need one. Come on.

SFX:
Jill's walking noise.

4

5

6

"I think that at its core, visual-effects animation is the same discipline as character animation for television or **feature** films," says Charles Alleneck, a senior animator at Lucasfilm's Industrial Light & Magic (ILM). "Essentially, we follow the same fundamentals. Often we have to tone down those principles to make things look more 'real' and not cartoony. For instance, things like squash-and-stretch and anticipation, while still present, tend to be much more subtle in effects animation. All of those principles were developed by animators seeking to distill or exaggerate reality, so they are heightened from the real. Since we are trying to emulate reality, we still have to understand how and why those principles are at play, but not exaggerate them as strongly as one would in traditional animation."

1. Action lines tracing the movement of a simple character by animator Ty Varszegi.
© 2008 Ty Varszegi

2. Pitch boards by storyboard artist Ryan Sias (ryansias.com) for proposed animated TV series, *Fergison's Neighborhood*.
© 2008 Ryan Sias

3–6. Stills from the stop-motion/live-action work of independent animator Devin M. Ruddick (devinmruddick.com).
© 2008 Devin M. Ruddick

History and culture

Across time

The history of digital animation, which is little more than 50 years old, is just beginning to be written. American animator John Whitney created the first analog computer graphics in 1957, and Ivan Sutherland invented the first computer drafting program, Sketchpad, at MIT Lincoln Laboratory in 1963. Through the 1960s and 1970s researchers at and around the University of Utah, including Fred Parke, Alan Kay, and Ed Catmull (later cofounder of Pixar), expanded the realm of possibility for 2D and 3D graphics and animation.

Since the late 1970s there has been such rapid growth and such widespread development in every aspect of digital animation that even the foremost innovators could not have fully predicted all that has transpired. (See pages 166–168 for animation history resources.)

According to animation historian, theorist, and professor Harvey Deneroff (deneroff.com), "Computer animation opened up a new field of dimensional animation. In other words, it provided a whole new tool set for filmmakers. This not only opened new vistas for animation filmmakers, it also opened up new avenues for the field of visual effects.

"The introduction of digital technology largely erased the artificial distinctions between live action and animation as separate categories of filmmaking. It has led some film and animation theorists and historians to start treating animation and live-action filmmaking as much the same. This has been reinforced by the recent trend of live-action filmmakers, such as Robert Zemeckis, to move into animation, which was once, at best, a rare occurrence."

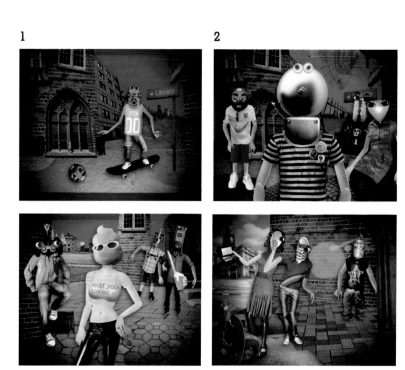

1

2

3

4

5

6

7

1–4. Stills from mtvU on-air promos, directed by Piyush Raghani. Animation design and direction: Gayatri Dixit and Sameer Kulavoor. Sound design: Amartya Rahut.

5–7. Stills from MTV Big Picture on-air promos, directed by Piyush Raghani. Illustration, animation design, and direction: Gayatri Dixit and Sameer Kulavoor. Sound design: Darshan, Famous Studios.

8–11. Stills from MTV First Cut on-air promos, directed by Piyush Raghani. Animation design and direction: Gayatri Dixit and Sameer Kulavoor. Sound design: Darshan, Famous Studios.

All images
© 2008 Gayatri Dixit
and Sameer Kulavoor

8

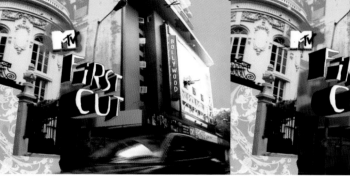

9 10 11

Around the world

The largest and most successful markets for animation have traditionally been the US, Canada, the UK, continental Europe, Australia, and Japan. But with the near-ubiquitous trend of outsourcing animation production work to areas of the world where wages are lower (particularly South Korea, the Philippines, and India), and with increasing competition from the emerging economies of Brazil, Russia, India, and China (collectively referred to as BRIC), the economic landscape of animation is changing, and the cultural landscape is evolving along with it.

The combined power of film exporting, satellite television, international film festivals, and the Internet has brought about a cross-pollination of animation techniques and styles like no other period in history, yet at the same time there is an abiding sense of cultural diversity and personal identity among independent animators worldwide.

Indian animation

Sameer Kulavoor (sameerkulavoor.com) and Gayatri Dixit (gayatridixit.com) are Mumbai-based designers and directors of animation. They have created broadcast packaging, promos, music videos, illustrations and designs for ad campaigns, and brand identities for a slew of clients such as MTV, Soda Films, electronica outfit Pentagram, and agencies such as Ogilvy & Mather, Lowe, JWT, and Leo Burnett. Dixit also works as an art director and designer at MTV India, and Kulavoor provides illustration, design, and animation services to clients ranging from multinational corporations to magazines and musical acts.

"The animation industry in India is definitely booming," says Kulavoor. "India has a tradition of great storytelling and a unique aesthetic that waits to be explored. Communities like The Animation Society of India (TASI) are working hard to bring together the community and to create awareness."

Writing for animation

Sometimes writing for animation requires no words at all. Independent animators especially often conceive and construct their films solely through images—writing by drawing. Sketched sequences and storyboards can take the role of the traditional "script," and dialogue (if any) may be worked out only after the "story" is completed.

In fact, the screenplay-style script is a late-comer to animation and began mainly with the advent of mass-produced television animation around 1960. Today, in dialogue-driven shorts and larger productions, a script has become a prerequisite, both as a storytelling tool and as a template for recording dialogue.

Script formats vary according to form, genre, studio, and director, but the fundamentals of story, character, and world building remain the building blocks for any animation writer. All the writer needs is an imagination and the ability to translate his or her visions into words that involve and inspire other artists.

1

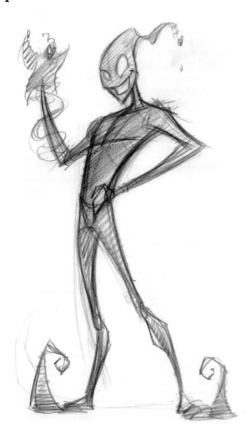

1. Character sketch of Knockabout by Paul Gutierrez.

2. Character sketch of Violin Death by Paul Gutierrez.

Script page for *Knockabout: Death By Violin* written by Steven Withrow. Knockabout and Violin Death © *and* ™ *2008 Steven Withrow and Paul Gutierrez (gotgutz.com).*

2

Sample television animation script

ACT 1
FADE IN:
EXT. DOWNTOWN CITY STREET - DAY

Knockabout, riding atop a city bus, leaps down to the street and ducks into an alley.

HIGH ANGLE IN THE ALLEY - MOVING

TRACK WITH Knockabout peering around the corner at the end of the alley.

CLOSE ON KNOCKABOUT'S EYES
scanning for the villain, then he suddenly REACTS and draws back into the shadows.

KNOCKABOUT'S POV

Violin Death runs from a smoking hole he created in the outer wall of the municipal bank. In one hand he holds a sack of money. In the other his killer violin still hums with power.

KNOCKABOUT (OS)
Hmm. Now there's someone who could really use a citizen's arrest.

ANOTHER ANGLE ON KNOCKABOUT
He scans around, then leaps nimbly onto the top of a nearby car, and springs from here onto the side of a building, bouncing off like an acrobat, his right arm morphing into a sledgehammer.

Storyboarding for animation

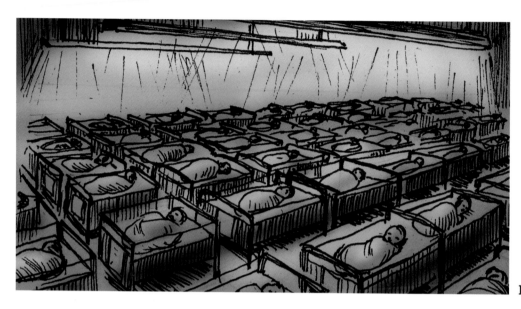

1

1–11. Storyboards by Rigel Stuhmiller for *Een Nauwe Poort* (*A Narrow Gate*), directed by Jonathan Fung.

12–21. Storyboards for "Bird," a 15-second piece of 3D animation, by Rigel Stuhmiller.

All images © 2008 Rigel Stuhmiller

Storyboards are a common tool in the previsualization (pre-vis) or design phase of all types of animations—from films and music videos to commercials and motion graphics—and in some cases take the place of a script. Each set of boards is essentially a comics version of the completed animation, composed mainly of the **keyframes** (collectively called a "shot list"), and often including written or drawn instructions for incorporating visual detail and specific movement. This helps an animator, director, or other creative technician to isolate problems in structure, pacing, narrative flow, and timing. Storyboards are also widely used in brainstorming sessions, and in pitching projects to clients.

Nowadays storyboards are often followed by simplified mock-ups, called **animatics**, to give a fuller sense of composition, timing, camera positioning, lighting, and motion in each scene or sequence. These are usually created in film-editing software, and are sometimes accompanied by a soundtrack that might include rough (scratch) dialogue, sound effects, and music. Editing the film at the animatic stage saves directors a great deal of time and money. Some animatics (mostly at the larger studios such as Pixar or DreamWorks) are as sophisticated as modern computer games.

For this section we will take a look at two storyboards by San Francisco–based illustrator and designer Rigel Stuhmiller (drenculture.com), who is best known for her vibrant, elegant prints, and her rich, layered illustration style. She has storyboarded for films, commercials, television, and music videos.

2–11

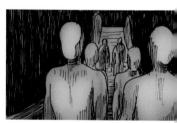
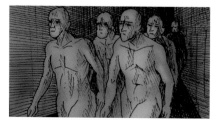
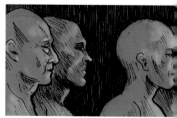

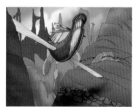

Een Nauwe Poort (A Narrow Gate)

This abstract film, showing the breakdown of humanity through ceaseless mechanization, was created for the dOeK Festival in the Netherlands (2004). The director, Jonathan Fung, knew that the film would consist of a loose narrative bolstered by collaged vintage stock footage, and that most of the specific storytelling would take place in the editing room. The location of the set had not been decided at the time the storyboards were made, and therefore, the storyboards needed to show the action taking place in very general locations. The main purpose of the boards was to help the director convey the mood of the film to his crew to produce a cohesive vision among members of set, costume, lighting, acting, and directing teams.

12–21

"Bird" storyboards

Stuhmiller created these storyboards to visualize a short segment of 3D computer animation she directed titled "Bird." Although the segment was only 15 seconds long, the action sequence was very specific and required detailed storyboards. These boards were also used to describe character and set design.

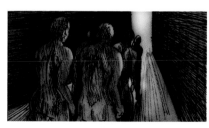
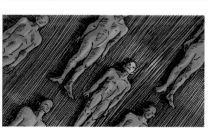
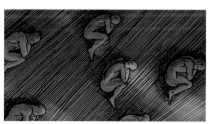
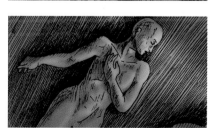

Character design for animation

1

The living character

Character designers in the field of animation use a range of artistic disciplines simultaneously, including anatomy, aesthetics, kinetics (the physics of motion), and dramatic expression. Mastering any one of these principles requires years of practice and instruction—rare is the animator who can balance the sometimes competing requirements of each to create a functional design that seems to *live* on the screen and not simply to move.

Character is a function of storytelling, and every element of characterization must work within a unified design that serves the story. Setting, genre, narrative structure, and format all directly affect the shape that an animated character ultimately takes. Every story has its own set of internally consistent "rules" that each character must follow. Put simply, what works well in one story might be completely wrong for another. For example, Wile E. Coyote, as drawn and directed by Chuck Jones for the classic Warner Bros. **cartoons**, is a brilliant design in its wild and zany context, but would be difficult, if not impossible, for the viewer to accept, without irony, within the world of Walt Disney's *Bambi*, though they both use the traditional 2D format and anthropomorphic animal characters.

2

The creative process

Character ideas often start through a process of free association or brainstorming, with quick sketches or thumbnails used to help solidify a mental image. Usually only the basic "construction lines" are drawn at this stage. These initial sketches are then developed through more refined contour, tonal, and color sketches, which in many cases evolve further into formalized **model sheets** that help to ensure accuracy and consistency of detail.

Model sheets are particularly useful when a designer must communicate quickly and efficiently with a group of animators. Common types of model sheets include color sheets, facial expression sheets, pose or posture sheets, costume sheets, and turnarounds or rotations. Lineups are also widely used; these show multiple characters side by side to highlight contrast in shape, scale, detail, and color. Visual contrast between characters is paramount for good design, as contrast generates conflict and conflict drives a story.

3

The value of caricature

For the animator, reducing a character to its essential silhouette—a simple, instantly recognizable shape—not only provides a good test for distinguishing multiple characters, but also isolates a character's fundamental iconic or symbolic power. Who, after all, can forget the silhouette of Mickey Mouse's circular head and ears, or the rounded triangles of Bart Simpson's hair?

Many animation theorists argue that caricature—distorting the essence of a person or thing through exaggeration or understatement to create an easily identifiable visual likeness—is more effective than literal interpretation. Humans, by nature, respond readily to "cartoons" and regularly invest emotion, thought, and meaning in the simplest of designs (the popular smiley face icon is a great example). We are all adept at creating and decoding anthropomorphic characters—animals, plants, or inanimate objects that exhibit human characteristics.

4

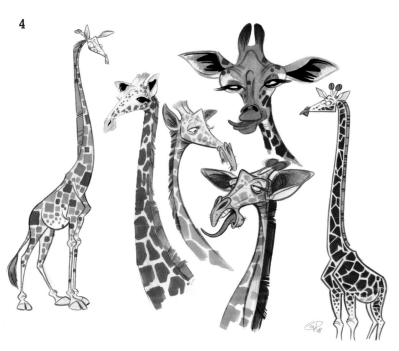

1–4. Character sketches for Ben Balistreri's graphic novel, *Seaweed and the Cure for Mildew* (self-published, 2008).

All images © 2008 Ben Balistreri

Skill profile: Characters of Ben Balistreri

Ben Balistreri [benbalistreri.blogspot.com] has worked as a character designer and storyboard artist in the animation industry since 1997. After attending the University of Arizona and the California Institute of the Arts' (CalArts) Character Animation program, he began his career at Disney TV. Since then, he has worked for Nickelodeon, LAIKA, Universal Studios, Cartoon Network, and DreamWorks.

Balistreri is an Emmy Award–winning character designer for *Foster's Home* for *Imaginary Friends* at Cartoon Network. He has also been nominated for five Annie Awards (presented by ASIFA-Hollywood): three times for outstanding storyboarding for a television series for his work on the Nickelodeon series *Danny Phantom*, and twice for outstanding character design—for *Danny Phantom* and *Crash Nebula* (also from Nickelodeon). He has recently completed work on his first graphic novel, *Seaweed and the Cure for Mildew* (self-published, 2008).

1

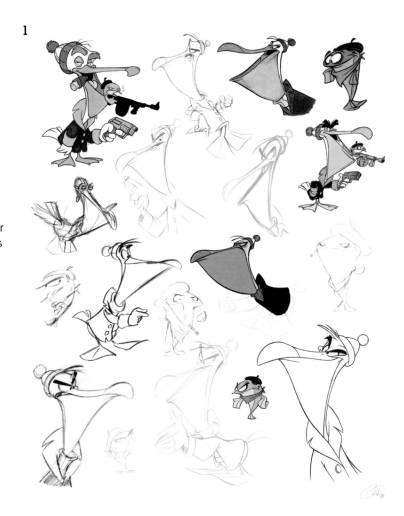

1–4. Character sketches for *Seaweed and the Cure for Mildew*.

All images © 2008 Ben Balistreri

2

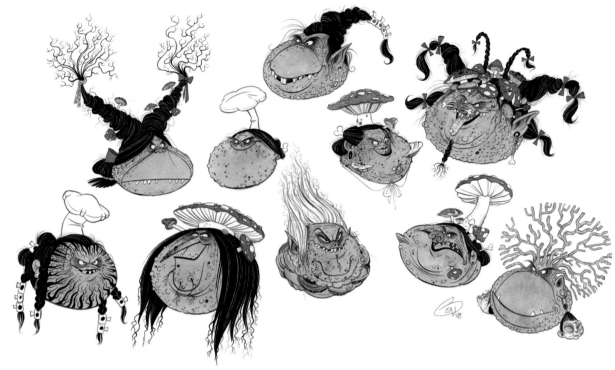

3

4

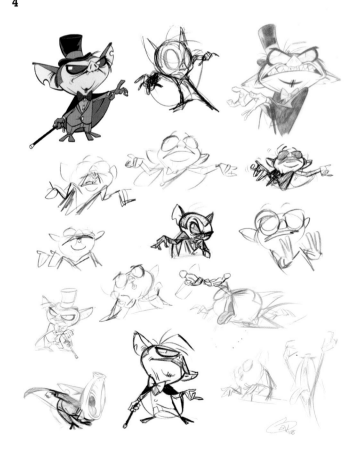

Balistreri on designing characters

My approach to character design, whether it's for comics or animation, is to start with who the character is. A designer must believe that this is a living, breathing character with a history, goals, personality quirks, and unique traits.

I believe in researching every aspect of the design I'm creating. Research makes a designer's job much easier. If I need to design a giraffe's spots, I could struggle to come up with a pattern that feels right and is visually interesting, or else I could study the real thing and stylize the pattern to make a unique and beautiful design.

That's not to say I want to replicate nature or life to a photo-realistic degree. Caricaturing life is what animation does best, and I believe all observations should be pushed, simplified, and stylized to maximize the character I'm portraying.

Once I have the ideas and research to support me, I work to create an appealing, simplified structure for the character. This involves no detail, but focuses on creating a design that is simple enough to draw over and over, has a clear silhouette, and has interesting shape variation. I'm not worried about the character's pose or expression—those can be manipulated later. I do make sure the perspective on the character is correct by picking an imaginary horizon line and making sure that my design fits on it.

I draw through all the shapes, even on a flat graphic design, so that the structure will be consistent, appealing, and believable. I think you destroy the illusion of life when forms don't connect properly. The initial design structure is achieved by drawing lots of quick sketches to try out different ideas. Once I decide which basic idea I'm going with, I draw over it several times, pushing the shapes and proportions until I get the structure I want.

And when that's done, I've earned the right to add all the fun details!

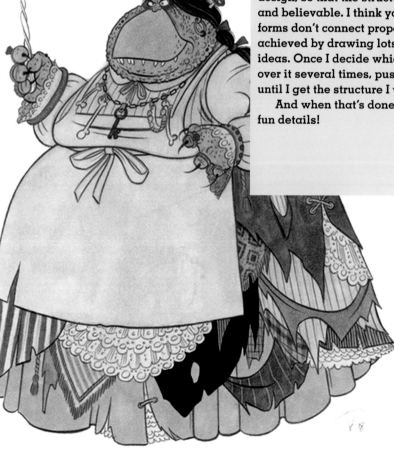

5. Page from *Seaweed and the Cure for Mildew.* Balistreri brings an animator's sense of motion, staging, acting, silhouetting, and timing to every one of his comics' pages.
Image © 2008 Ben Balistreri

Skill profile: Motion graphics of Nigel Holmes

1

2

4

Motion graphics are the nexus of **information graphics**, multimedia, and animation. Nigel Holmes, a well-known expert in the infographics field, and Principal of New York graphic design firm Explanation Graphics (nigelholmes.com), discusses "Vampire Energy" (originally published in *GOOD* magazine, December 2007).

As part of *GOOD*'s "transparency" feature (an eight-page infographics section devoted to interesting statistics in every issue), Holmes created a graphic about the cost of "vampire energy," that is, electricity that leaks out of appliances when they are plugged in, even if they are turned off.

"So it started out as a print graphic," says Holmes, "but *GOOD* had initiated a program of turning some of the graphics from the magazine into short videos for its website (goodmagazine.com) and YouTube. During the transition from static print to full motion and sound, I learned a lot about displaying data in the two different media, and in fact, the video bears little relation to the print piece, except in obvious graphic ways—I used the same drawings in both."

3

1–7. Stills from "Vampire Energy."

All images
© 2008 Nigel and
Rowland Holmes

The script was written by Morgan Currie and others at *GOOD* magazine, but went through revisions as Holmes was preparing the flow of images, and again when he recorded the voice-over, with sound by Lenny Stea.

Every thought or phrase in the script was recorded separately so that the animator (Holmes' son Rowland) could attach them to exact moments in the visuals without having to cut up and edit one long audio file. The pair had followed this method for a number of other short films they had worked on together. They used Adobe Illustrator to draw the images, Adobe Flash to compose the animation, and QuickTime Pro to edit the animation.

Holmes on the future of graphics

Sad as I am to say this, with the gradual demise of magazines and newspapers, and the continued rise of the web, print graphics will eventually be less and less the way we receive information, so motion graphics are surely the next phase for information graphics. Music, motion, and the spoken word add storytelling possibilities that are impossible in print alone.

Voice in particular is important because it can replace much of the often rather small-sized explanatory text in a graphic. A big problem with information graphics on the web is actually being able to read the text. But voice adds much more. It can be used to add emphasis, humor, seriousness, and even just a touch of humanity, especially since the subject matter of many information or data graphics can be dry and difficult to understand.

But for all the possible differences in approach, the design principles for me are the same in both media. To my mind, simplicity always wins. I hope that information designers do not go wild with all the new toys at their disposal. Too much sound, even too much animation, will kill the clarity of the message. But that does not mean we can't have fun.

5

6

7

Case study: Blender Foundation's *Big Buck Bunny*

The Amsterdam-based Blender Institute—a spin-off of the open source organization Blender Foundation—released the short 3D animated film *Big Buck Bunny* with a grand party at the hip Amsterdam cinema Studio K. Created by an international team using open source software, it involved a six-month production period.

"The primary intent of the movie was to stimulate the development of open source 3D software," says Producer and Institute Director Ton Roosendaal, "but the result equals on an artistic level, as well as on technical ingenuity, the quality you would expect from large animation studios."

The movie differentiates itself mostly by its totally open source character. Not only were open source tools, such as the 3D suite Blender, used to create the movie, but the movie itself, including all materials used in the animation studio, are available free "for everybody to reuse, to learn from, or just to enjoy." The film was **rendered** using Network. com's Sun Grid Compute Utility service.

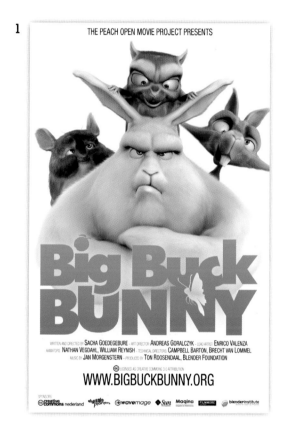

1

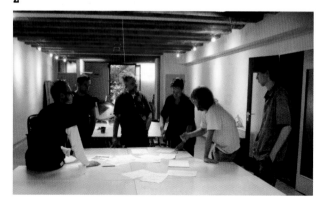

1. *Big Buck Bunny* movie poster.

2. The *Big Buck Bunny* team meeting in Amsterdam.

3–7. Preproduction art and storyboards for *Big Buck Bunny*.

Project team

* **Writer and Director:** Sacha Goedegebure (the Netherlands)
* **Art Director:** Andreas Goralczyk (Germany)
* **Lead Artist:** Enrico Valenza (Italy)
* **Animators:** Nathan Vegdahl (USA) and William Reynish (Denmark)
* **Technical Directors:** Brecht van Lommel (Belgium) and Campbell Barton (Australia)
* **Composer:** Jan Morgenstern (Germany)
* **Producer:** Ton Roosendaal (the Netherlands)

The promotion of OpenContent creation and distribution is one of the main goals of Creative Commons, the organization that developed the Creative Commons licenses which have been widely adopted by artists, musicians, and other creative individuals who wish to share their creative endeavors freely. Blender Institute in Amsterdam is one of the first companies in the world to exploit OpenContent professionally and commercially. During the first half of 2008, 14 people were working full time in the Institute, wrapping up *Big Buck Bunny* and working on an OpenGame based on the characters from the movie.

Big Buck Bunny is a comedy about an even-tempered rabbit, Big Buck, who finds his day spoiled by the rude actions of the forest bullies—three rodents. In the typical 1950s cartoon tradition, Big Buck then prepares for the rodents a comical revenge.

3

4

5

6

7

7

Blender links

Big Buck Bunny: bigbuckbunny.org
Blender Institute: blenderinstitute.nl
Blender: blender.org
Creative Commons: creativecommons.org

8

The Blender Institute brought the creative team for the movie together from all over the world, including the USA, Denmark, Italy, Germany, the Netherlands, Belgium, and Australia. The music was composed by Jan Morgenstern, who also provided the soundtrack for the previous Blender production, *Elephant's Dream*.

Big Buck Bunny has been released on 35mm film format as well as on DVD and Blu-ray disc. The film is now downloadable free for everyone, in various formats. The Blender Foundation and Blender community have been the main financiers of the film. A presales campaign encouraging purchase of the DVD set in advance of its release date has been organized. Additional support from sponsors and subsidy funds has been realized as well.

7–10. Stills from *Big Buck Bunny*.

All images © 2008 Blender Foundation, www.bigbuckbunny.org, and licensed under the Creative Commons Attribution 3.0

9

10

Artist profile: Nina Paley

Country of origin: US
Primary areas: Shorts, features, festivals, comic strips
Primary technique: Wide range of techniques
URLs: ninapaley.com; sitasingstheblues.com

Nina Paley is a longtime veteran of syndicated comic strips, creating *Fluff* (Universal Press Syndicate), *The Hots* (King Features), and her own alternative weekly *Nina's Adventures*. In 1998 she began making independent animated festival films, including the controversial yet popular environmental short, "The Stork." She teaches at Parsons The New School for Design in Manhattan and is a 2006 Guggenheim Fellow.

In 2002 Paley, who is mainly self-taught as an artist and animator, followed her then husband to Trivandrum, India, where she read *The Ramayana* for the first time. This inspired her first feature, the multiple-award-winning *Sita Sings the Blues* (82 minutes, 2008), which she directed, wrote, produced, designed, and animated single-handedly over the course of five years, on a home computer. The film premiered at the 2008 Berlinale festival in Germany, made a splash at the 2008 Tribeca Film Festival in New York, and has played in and won accolades at festivals around the world.

"*Sita Sings the Blues*," says Paley, "is a musical, animated, personal interpretation of the Indian epic *The Ramayana*. The aspect of the story that I focus on is the relationship

1–4. Stills from Sita's story in *Sita Sings the Blues*.

1

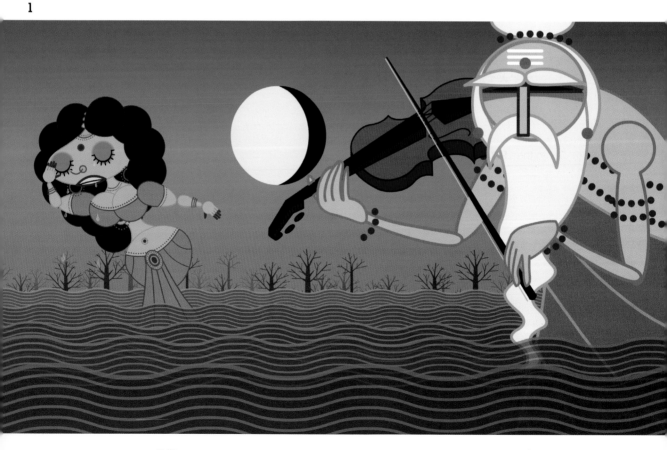

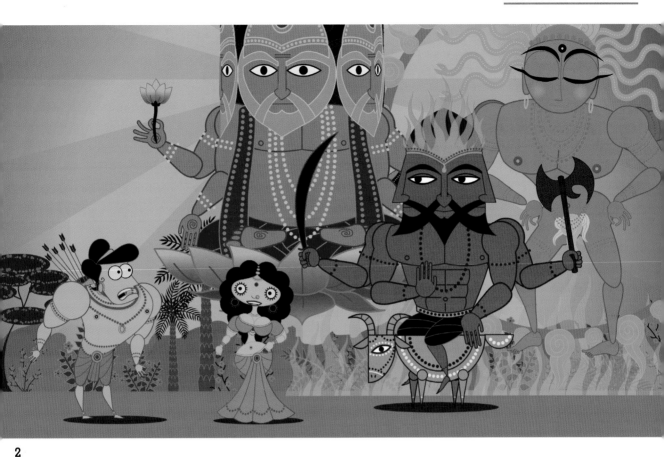

2

between Sita and Rama, who are gods incarnated as human beings, and even they can't make their marriage work."

The film's parallel narrative is more directly autobiographical. The character Nina is an animator whose husband moves to India, then dumps her by e-mail. Three hilarious shadow puppets narrate both ancient tragedy and modern comedy. Set to the 1920s jazz vocals of the late Annette Hanshaw, *Sita Sings the Blues* earns its tagline "the greatest break-up story ever told."

Paley told *Wired* magazine in April 2008, "I'm just an ordinary human, who also can't make her marriage work. And the way that it fails is uncannily similar to the way Rama and Sita's [relationship fails]. Inexplicable, yet so familiar. And the question that I asked and the question people still ask is, 'Why? Why did Rama reject Sita? Why did my husband reject me?' We don't know, and we didn't know 3,000 years ago. I like that there's really no way to answer the question, that you have to accept that this is something that happens to a lot of humans."

3

4

Personal production

Paley started on a Titanium PowerBook G4 laptop in 2002. She moved to a Dual 1.8GHz Tower in 2005, then moved again to a 2 × 3GHz Intel Tower in December 2007, with which she did the final 1920 × 1080-pixel rendering. She animated the film primarily in Macromedia Flash (she used an older version from before Adobe bought the product) with a little bit of rotoscoping, or tracing over live-action film movement. She made some original watercolor paintings by hand, which she scanned and animated in Adobe After Effects. She edited everything in Final Cut Pro.

Her main collaborators were sound designer and audio engineer Greg Sextro; the songs of Annette Hanshaw, composers and musicians Todd Michaelsen, Rohan, Rudresh Mahanthappa, Masala Dosa, and Nik Phelps; and narrators and voice actors Aseem Chhabra, Bhavana Nagulapally, Manish Acharya, Reena Shah, Debargo Sanyal, Sanjiv Jhaveri, Aladdin Ullah, Nitya Vidyasagar, Pooja Kumar, and Deepti Gupta. Jake Friedman apprenticed with Paley during the summer of 2005, and Ariel Lagares coded Paley's blog page.

5

Paley's budget for the film was US $200,000 (c. UK £111,000), plus the invaluable contribution of her own time. She raised most of the money on her own from freelance work, but also had the help of a 2006 Guggenheim Fellowship. In addition, she received donations from many people who read about the project online.

6

5–7. Stills from Sita's story in *Sita Sings the Blues*.

8 and 9. Stills from Nina's story in *Sita Sings the Blues*.

All images © 2008 Nina Paley

7

8

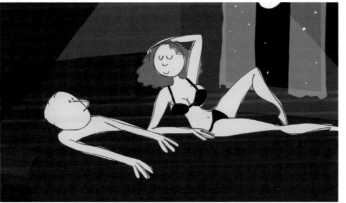

9

33

Artist profile:
Cassiano Prado

Country of origin: Brazil (now living in UK)
Primary areas: Broadcast design,
 commercials, music videos
Primary technique: Wide range of techniques
URL: cassiano.tv

1

1 and 2. MTV Europe Music Awards 2005 and Lisbon show packaging.

3. MTV *Senseless* title sequence (2006).

4. Identification (ident) for Mirrorball/Edinburgh Film Festival (2004).

5. MTV Films Europe, ident for cinemas (2006).

6. MTV Europe Music Awards 2005, tune-in spot promo.

7. MTV Europe Music Awards 2005, Lisbon teaser.

2

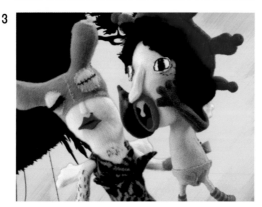

3

Director, designer, and animator Cassiano Prado was born in São Paulo, Brazil, where he later earned a degree in Social Communication from the Pontifícia Universidade Católica de São Paulo. While still at school he joined the largest visual effects (VFX) house in Latin America, Vetor Zero, as an Autodesk Inferno artist. Craving a more creative role a year later, Cassiano made his way into Lobo's design team as a motion-graphics designer, publishing his work internationally for the first time.

Relocating to London in 2002, Prado quickly immersed himself in creative work, designing and art-directing for major studios such as INTRO, Passion Pictures, and Nexus Productions. In 2005 he was invited by MTV International to direct the MTV Europe Music Awards 2005 campaign, which led to two years of on-staff work for MTV International and MTV UK, directing promos and show packaging. Since then, the scope of Prado's work has broadened from mainly broadcast design to global commercials and music videos.

Electrelane's "In Berlin"

In 2007, Prado directed the music video for the song "In Berlin" by the band Electrelane, from Brighton, UK (cassiano.tv/pop/inberlin. htm). The video went on to win the Audience Award at IAFF ReAnimacja 2008 in Lódz, Poland (see images 10–12).

"Although it began with a commercial nature, the project became more of an art project than a commissioned piece of work," says Prado. "The reasons for that were that there was no budget from the record label, which meant freedom in this case, and I was dealing directly with the band, who were always very excited about the direction the treatment was evolving toward."

The melancholic track, the band's favorite, reminded Prado of a sort of existentialist drama. "The beginning and the end of a relationship, of a season, of a life. By the time I was immersed in the track, brainstorming the idea, I happened to stumble across an Antony Gormley exhibition in London which was just spot-on in relation to everything bubbling in my mind. The concept had a lot to do with that. I just had to interpret it in my own way."

4

5

6
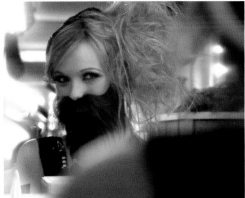

7
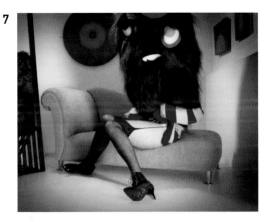

Video credits

* **Band:** Electrelane
* **Track:** "In Berlin"
* **Duration:** 4 minutes 5 seconds
* **Production Company:** emenes GmbH/ Nois.tv
* **Label:** Too Pure/Beggars
* **Director:** Cassiano Prado
* **Assistant Director:** Andrezza Valentin and Alfredo Hisa
* **Executive Producer:** Marko Zawadzki
* **Art Director:** Andrezza Valentin
* **Producers:** Tupaq Felber and Nick Grgic
* **Designer:** Mario de Toledo-Sader
* **Editor:** Cem Kaya
* **Directors of Photography:** Alex Carvalho and Liz Smith
* **Sound effects:** Paulo Beto
* **3D Supervisor:** Jerome Haupert
* **3D modeling, rendering, and lighting:** Jerome Haupert
* **3D character animation:** Alfredo Hisa

8

9

The piece began to take form after brainstorming sessions between Prado and the video's art director Andrezza Valentin, who suggested that the pictures of American photographer Francesca Woodman had the right mood for what the team wanted to get across. "Although only Polaroids, Francesca's stills can tell long stories," Prado says.

"Although I wanted this to be a visually stunning piece of work, I focused my efforts on the storytelling and the fact that it should be totally in tune with the track. It was a tricky track, with an unconventional pace, and the video would have to be interesting enough to grab the audience attention until the end."

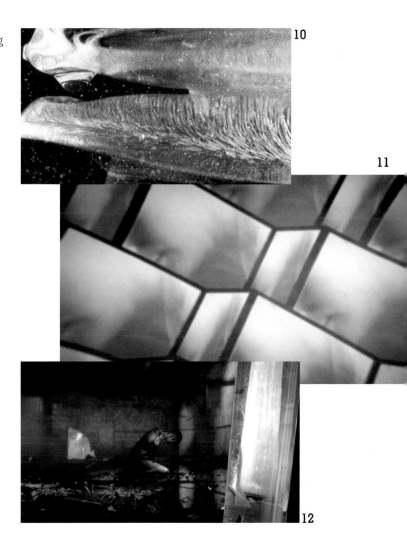

10

11

12

8 and 9. "Zeroum" live visual and viral video (2008).

10–12. Stills from music video for Electrelane's "In Berlin" (2007).

13–20. 4Music *Buzz Charts* title sequence (2008).

All images © 2008 Cassiano Prado

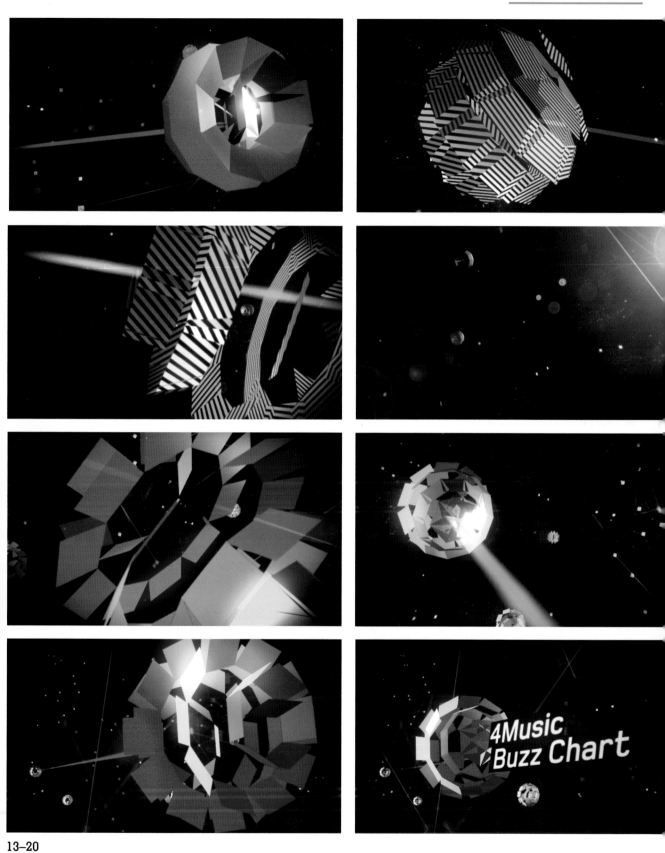

13–20

Artist profile: Michael Knapp

Country of origin: USA
Primary areas: Feature films, shorts, comics
Primary techniques: Art direction, design
URLs: michaelknapp.com, outofpicture.com

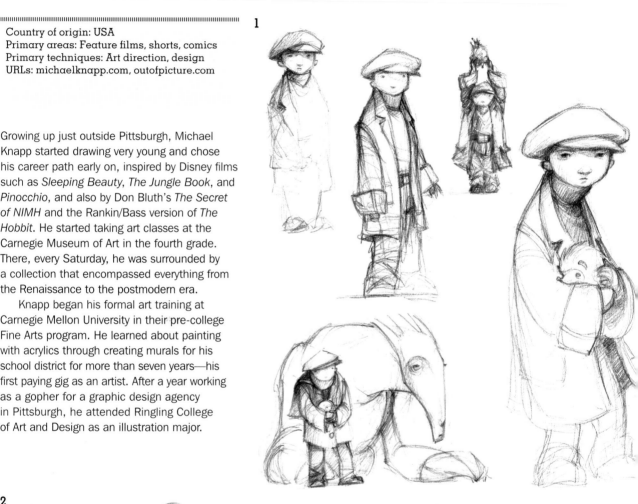

1

Growing up just outside Pittsburgh, Michael Knapp started drawing very young and chose his career path early on, inspired by Disney films such as *Sleeping Beauty*, *The Jungle Book*, and *Pinocchio*, and also by Don Bluth's *The Secret of NIMH* and the Rankin/Bass version of *The Hobbit*. He started taking art classes at the Carnegie Museum of Art in the fourth grade. There, every Saturday, he was surrounded by a collection that encompassed everything from the Renaissance to the postmodern era.

Knapp began his formal art training at Carnegie Mellon University in their pre-college Fine Arts program. He learned about painting with acrylics through creating murals for his school district for more than seven years—his first paying gig as an artist. After a year working as a gopher for a graphic design agency in Pittsburgh, he attended Ringling College of Art and Design as an illustration major.

2

While this started out as the path to working in animation (Walt Disney Studios recruited from Ringling each year), he decided during his first year that he didn't want to begin his career as an in-betweener (the traditional entry-level position at Disney), so he focused solely on illustration.

He now works at Blue Sky Studios as art director on the third *Ice Age* movie. He previously worked as a designer on the animated films *Robots*, *Ice Age: The Meltdown*, and *Dr. Seuss' Horton Hears a Who!*, and spent a few months art-directing the Academy Award–nominated short *No Time For Nuts*. His work can be found in *Spectrum* 12 and 13 and the *Society of Illustrators Annuals* 48 and 49.

He is the book designer and coproducer of the animator-centric comics anthologies *Out of Picture*, Volumes 1 and 2 (Villard, 2007 and 2008), which include his stories "Newsbreak" and "Under Pressure: A Breakerboy Chronicle."

Knapp's list of influences ranges across the visual arts, from illustrators J. C. Leyendecker and William Joyce, to cartoonists Chris Ware and Bill Watterson, to directors Terry Gilliam and the Coen brothers. What appeal most to him, he says, are a strong graphic sensibility, a great sense of color and atmosphere, and a sense of humor.

1. Studies of the Breakerboy character for Knapp's comics story *Under Pressure: A Breakerboy Chronicle*.

2. Sketches of the Foreman character for *Under Pressure: A Breakerboy Chronicle*.

3. Studies of Lenny the Lizard, a confused reptile who thinks he's a news reporter.

3

Michael Knapp on character development

For films, the development of a character is entirely a collaborative process with the director, possibly the producer, and usually the art director. Once the look of the character is established, then a lot of consulting with the other departments takes place—modeling, rigging, animation, and materials—and the design gets tweaked to work better or perform better in 3D while still maintaining the spirit of the original design.

When working with a director, my process is more iterative than intuitive (at least until I get a real understanding of their sensibilities, then hopefully it takes fewer iterations to nail a character). But my personal process is very intuitive. I'll usually start out simply sketching in a loose way, then start refining the silhouette until I find proportions I like. Then I try to find the types of poses the character might take and see what works and what doesn't. And once the character starts to shape up, I do a lot of studies from different angles to see what the best ways to frame the character might be, and what angles to avoid.

Color usually comes a little later in the design process. The palette of a character can say a lot about them metaphorically, but it can also be a clear way to make a character stand out from other characters, or from their surroundings. Needless to say, a color image is generally more gripping than a monochromatic version of the same image, so when pitching ideas, color is an extremely useful tool (if well executed). Still, it's extremely important to nail down your black-and-white value structure before diving into color. If your value range isn't figured out, color is only going to confuse things more.

I think a successful character has to be relatable to the viewer on some level, even if that character is a villain. The treatment of the eyes is very important. This is something I'm always experimenting with, whether exaggerating them or trying to hide them altogether. Being able to empathize with a character is extremely important. This may come down to the writing, ultimately, but if you can find the right gesture, expression, or mannerism, a character has the potential to connect with the viewer without saying a word. Economy is also really important. How much information about a character can you convey in as few pencil strokes as possible? The simpler a character—the more distinct the silhouette—the more recognizable the character will be. The last thing I can think of is the costume. A solid costume design can tell volumes about a character, if thought out properly.

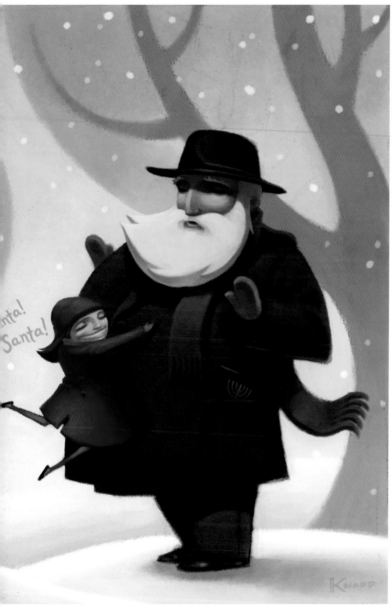

Art direction versus design

As art director, Knapp is involved from very early in the development process all the way through to **color timing** and **filmout**. First and foremost, his role is to develop the look and visual flow of the film, then help guide the designers and color artists through the big picture of the movie, making sure everyone is on style, and making sure the color work fits into the logic of the color script that he develops. Then, as the artwork is delivered to the subsequent departments—**layout**, modeling, materials, sequence dressing, lighting—he works with those departments and helps them in the interpretation of the artwork that has been generated.

"I still do some artwork," Knapp says, "but most of it is done in the early development process, and it tends to be loose conceptual work, not the polished detailed designs that I would do as an environment designer."

As a character/environment designer, he is involved with the modeling process, the materials process (if he has also done the color callouts for the environment or character), and then the set-dressing process. "Pretty much the first half of production is working with the departments that would have to interpret my artwork. It's an interesting process, because every single line drawn carries repercussions for other departments, so you always have to be conscious of other departments' needs," he says.

4. Santa Claus illustration for Christmas card.

5. "Night of the Toaster Coat" illustration about the invention of the electric coat, first published in *Pitt Magazine*.

5

6

6–8. Various scenes and environments from *Under Pressure: A Breakerboy Chronicle*.

9 and 10. Character sketches and color image from *Newsbreak*.

All images © 2008 Michael Knapp

7

Creative process

Knapp's primary tools are a pencil, a scanner, a Wacom Tablet, and Adobe Photoshop software. "I'm no modeler," he notes, "but I'll occasionally mock up some rough geo [**geometry**] in Maya to flesh out the basics of an environment if a space is difficult to visualize on paper. I prefer to do my sketching in pencil rather than on the Wacom. I really miss the grit of the pencil on the page when I'm doodling on the Wacom. However, I do all my painting with the Wacom once the pencil drawing is scanned into Photoshop. Granted, the more drawing you do on the Wacom, the less time you spend scanning, but I still prefer the old-fashioned way for my drawings."

8

Whether for animation or comics or even illustration, story is definitely king, and having solid story context makes for richer characters. According to Knapp, how a character carries him/herself, how the character plays against other characters, how the character moves—these are all important things to keep in mind while designing. "The more you know about the character, the more nuance you can give it, and the more memorable and relatable it will be."

When designing for production, nearly every design requires the creation of some form of model sheet or color callout for downstream departments to use. For his personal work, Knapp usually does just enough reference studies for consistency, but he's nowhere near as thorough as he is when working on a production.

9

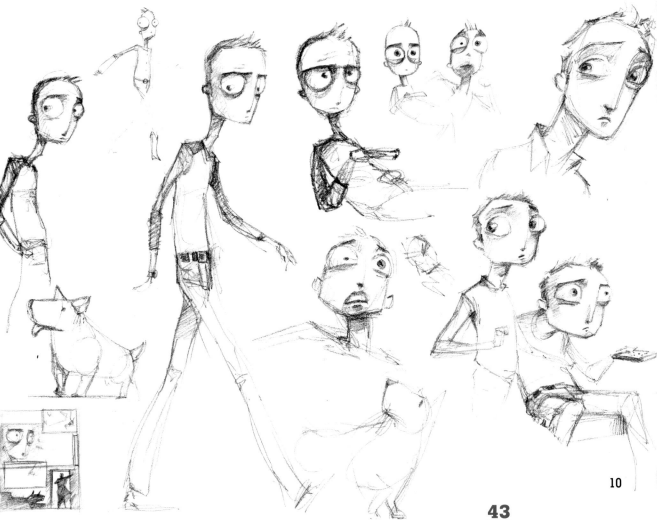

10

2
2D Animation

2D workflow

There is such a wide variety of approach to 2D animation that a standard **pipeline** has not developed in quite the same way as it has for 3D animation. Still, many animators follow the live-action film convention of dividing work on a project into three stages:

1. development/preproduction;
2. production; and
3. postproduction.

Simply put, development/preproduction generally involves researching, scriptwriting, storyboarding, character/layout design, previsualizing, scheduling, financing, and voice casting. Production is the animation work itself, guided by the director. Postproduction encompasses mainly **compositing**, editing, sound and music recording, title designing, rendering, marketing, and distributing.

Michael Sporn's *POE*

While production matters form the central content of this book, and postproduction will be touched on only briefly, the focus here is on the preproduction work for master filmmaker Michael Sporn's in-progress feature, *POE* (michaelspornanimation.com). *POE* is an animated biography of Edgar Allan Poe. It gives several long vignettes that relate key moments in Poe's life, and will also include four of his short stories and two of his poems.

Says Sporn, "*POE* has been in process for a couple of years now. We were given a bit of cash to start the project, and we produced a script, a storyboard for about two-thirds of the film, and a lot of preliminary drawings. We also produced about 10 minutes of animatic. This is pose-reel material, all of which is focused on the biographical section of the film. All work for this film will be done by a small crew of five or six people in New York City. Maybe more will be added at the end—if there's a crunch to complete it."

To date, two people have done storyboard work on *POE*. Jason McDonald boarded three of the stories: "MS. Found in a Bottle," "The Premature Burial," and "The Black Cat." Sporn boarded one story, the longest section of the film, "The Murders in the Rue Morgue."

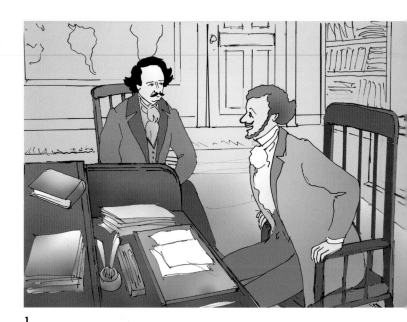

1

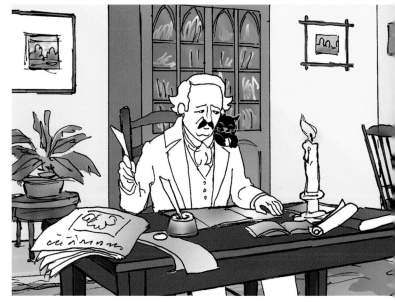

2

3

Rather than storyboarding her section of the film, master animator Tissa David has chosen to go directly to animatic. This means she is posing about every sixth drawing of her section—about 20 to 30 minutes of the film—as a preliminary to animating it. "For the animatic," says Sporn, "we recorded some rough voice-overs, which weren't always up to snuff. We've since replaced two of the voices with celebrities who will be our final voices. Hugh Dancy did a brilliant turn as Poe's voice, and has kicked enormous life into the project for us. Alfred Molina did two voices: Poe's first editor, George Graham, and the husband in 'The Black Cat.'"

Matthew Clinton animated the scenes completed to date. For the most part he did this by animating drawings on paper, then scanning them into a computer. The animators prepare and color the artwork using Adobe Photoshop. They then pull those files into Adobe After Effects, where they composite the work, then export QuickTime movies to Apple's Final Cut Pro, in which the piece is edited.

A **pencil test** is created after the animation is done. This provides an opportunity for the animators and the director to look at the movement and gauge how well the action works both within the scene and within the body of the overall film. This is done at the height of production and is not part of preproduction.

"Currently, we are doing test animation, looking at movement patterns and planning ways of animating in an eccentric drawing style," says Sporn. "We have to find the most expeditious way to make it look like the etching/woodcut style we've hit on."

4

1 and 2. Stills from biographical sections of the in-progress version of *POE*. (Note that the images on this spread are not final art, but rough working models, colored-pencil tests to provide samples of the direction in which the animation is going.)

3. Storyboard sequence from "MS. Found in a Bottle."

4. Rough still from "The Premature Burial."

All images © 2008 Michael Sporn Animation, Inc.

47

Workthrough: Chris Georgenes on Flash animation

Character design using Adobe Flash

There's nothing more intimidating than a blank canvas. Deciding how to draw that first line can sometimes take hours. If creating characters for animation is unfamiliar territory for you, this artistic process can become exponentially daunting. Adobe Flash, a globally popular 2D drawing and animation program, introduces a unique set of challenges for the designer and animator.

How do you design a character with each body part distributed across individual layers, and move them over time? How do you make them talk, walk, and express emotion? You'll be glad to know that animators around the world have developed several character-animation techniques using Flash. The coolest thing is, whether you are an old-school animation purist or a complete newcomer, the skill of animating in Flash is within your grasp. The first thing to consider is your desired animation style. Flash is pretty versatile because it allows for "pose-to-pose" animation as well as "cutout" style animation. What's the difference? Well, pose-to-pose animation is the technique of drawing each **frame** from start to end. It may sound simple, but it often takes a skilled artist with the ability to draw and animate in a very expressive and spontaneous way.

Cutout animation is one of the oldest techniques. It involves animating flat objects such as computer graphics, photographs, or materials cut from paper. *South Park*, which started out as real paper cutouts shot with film, is probably the best modern example of cutout-style animation. This TV show remains true to its original style, but now takes advantage of the speed and efficiency of computer animation programs to achieve the same look.

The coolest aspect of computer-animation programs like Flash is the opportunity they give you to combine methods from both traditional and digital animation. I am often asked by newcomers to the Flash world, "Should I use

Chris Georgenes

A self-taught animator, Chris Georgenes (mudbubble.com) spent six years as Director of Creative Development for Soup2Nuts, a division of Scholastic, where he art-directed many animated TV shows including *Home Movies* on Cartoon Network. He left to start his own animation company (Mudbubble, LLC), and also started Keyframer.com, a vibrant Flash resource and online community. In recent years he has undertaken numerous high-profile projects for Adobe, Yahoo!, Digitas, Ogilvy, Gillette, AOL, and Pileated Pictures, to name a few. He is also a featured artist at the Adobe Design Center and an Adobe Certified Expert. He is a regular speaker for the Flashforward Conference and Adobe MAX. He is also the author of *How to Cheat in Flash CS3* (Focal Press, 2007), and a contributing author for Colin Smith's *How to Wow with Flash* (Peachpit Press, 2006). Georgenes also teaches a Flash character animation course he developed for Sessions.edu, the online school of design. He is currently the Art and Animation Director for Acclaim Games. He lives in Massachusetts, USA.

All images © 2008 Chris Georgenes

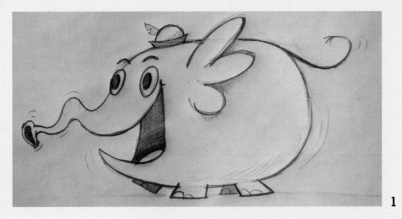

1

motion tweens, **shape tweens**, or pose-to-pose animation for my project?" My response is always the same. "Why limit yourself to just one technique? Use the method the animation calls for." My background is in the fine arts, and I have never attended an animation class. My experience as an animator has been solely through trial and error, and a willingness to explore without fear of making mistakes.

Flash animation allows us to play back our work instantly, giving us immediate feedback. This is useful for checking the overall timing of an entire animation sequence, or a short series of hand-drawn frames.

Flash also allows us to combine the best of both worlds by integrating old-school frame-by-frame animation with motion tweens. For this example of Flash character animation, cutout style is the easiest technique. It also produces very small file sizes suitable for delivery via the Internet, making it a popular choice for web-based cartoon series, games, applications, mobile content, and beyond.

The first step in designing a character in Flash is to draw it in three-quarter view—the angle between profile and straight on. This is the most versatile view because it allows us to see most of the character's face, including both eyes, which is important in helping the viewer to connect with the character on an emotional level. This view also allows us to animate a walk cycle and have the character walk across the "stage" in either direction. We can also animate the eyes to look left, right, or straight at the "camera."

1. Character sketches
Typically, I begin with pencil and paper. There's something about drawing on paper with lead that I still find aesthetically appealing.

If you prefer to remain completely paperless, you can draw straight into Flash using the program's drawing tools. Adding a high-quality graphics tablet that supports pressure sensitivity is almost mandatory if you plan to draw directly in Flash. Using a mouse to draw anything is about as intuitive as drawing with a brick.

2. Drawing in keyframes
After importing the scanned drawing into Flash, I insert a blank keyframe (indicated by a black dot) next to it, and then turn on the Onion Skin feature, which allows me to draw in frame 2 while seeing a "ghost" image of the scanned bitmap on frame 1.

2A

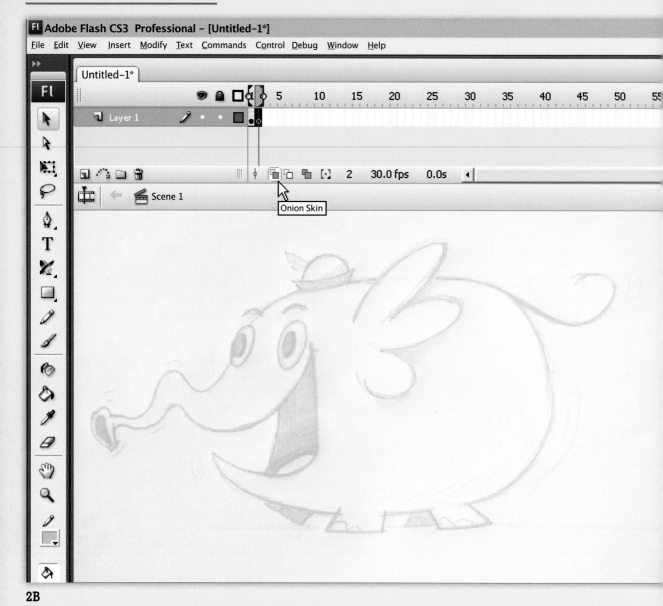

2B

3. Drawing the basic shapes

I draw using a combination of shape tools, brushes, and sometimes the Pen tool. I have no set rules as to when I use one tool over the other—it often comes down to the look and feel I am trying to achieve. In the case of Bilbo the elephant, I wanted a flat, cutout style with no outlines. I also use Object Drawing Mode while drawing the basic shapes. Object Drawing allows several different shapes to be drawn over each other without them "cutting in" to the shape below. I use my original sketch as a guide only, making design changes along the way as I see fit.

I always convert my objects to symbols and name them with a simple yet descriptive naming convention—for example, "head1," "eye1,"

"mouth_wide," and so on. In Flash a symbol is an object that resides in the document library. Any object can be converted to a symbol and reused throughout the **timeline** without increasing download times when the .swf (Flash-native file) is viewed online. However, I do not create names for my layers at this stage because there is a much easier and faster way. After all my symbols are created and named appropriately, I simply select them all (Ctrl+A) and copy them (Ctrl+C). I then create a new layer and paste them in place (Ctrl+Shift+V). This places them all on one layer, yet still as separate symbols. Delete all your other layers so that you end up with just the one layer containing all of your character symbols.

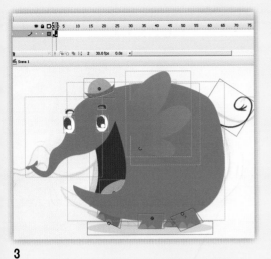

3

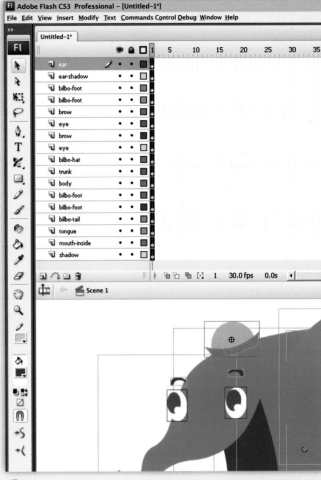

4A

4B

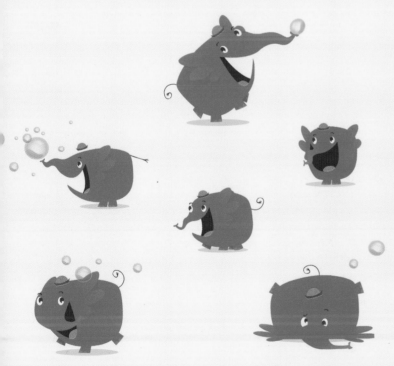

5

4. Naming symbols and layers

The next step is the coolest part. Select all your symbols again and then right-click over them to bring up the Context menu. Select Distribute to Layers. Presto! Flash has not only placed each symbol on its own layer, but also named each layer based on its symbol names.

5. Character poses

For this character I designed several views and poses based on his energetic personality. Bilbo is a happy-go-lucky circus elephant who is also a bit clumsy. I find it helpful to draw several gestures that reflect the personality of the character.

The walk cycle

I often do several different **walk cycles** for a single character. I start with a basic walk cycle, then a run cycle, perhaps a bouncy walk, or even a slow, sluggish walk depending on what the animation calls for. My Bilbo character is rather rotund and somewhat hyper, so I wanted him to "feel" like a big bowl of gelatin while still looking light on his feet. For this example I chose to design a profile view for the walk cycle animation.

Once my character was ready for animating, I selected a leg symbol and converted it to a new Graphic symbol called "bilbo-foot-walkcycle." Here, inside this symbol, is where I animate the leg "walking." This is a powerful Flash animation technique referred to as "nested" animation. The basic idea of nested animation is to have an animation inside a "container" or symbol— think of it as a movie within a movie.

The advantage of this is that it allows you to edit the properties of an entire animation by scaling it or changing its position over time. Camera pans and zooms are simulated in Flash by motion-tweening a symbol containing an entire animated scene across the stage. Of course, the scene is designed to be much larger than its stage. The reason I nest this animation is so that I can reuse it later for the other three legs. It is a very fast and efficient way to animate.

1. The leg "graphic symbol"

The first thing I do is edit the center point of my object. To do this, I select the Free Transform tool and the symbol. The center point is represented by a small, solid white circle. The Free Transform tool allows me to reposition the dot by dragging it anywhere I choose. Here I have positioned it so that the leg will be "hinged" where it connects with the body when rotated.

Repeat this process for each body part you want hinged. The center point of each individual symbol can be moved, as can the center point of multiple symbols, depending on how many are selected at one time. This is very useful for editing the center point of, say, the head of a character that contains multiple symbols (eyes, pupils, mouth, etc.), or an upper and lower arm and hand—in this case make the center point of all three at the shoulder. You can even edit the center point of multiple symbols across multiple layers! Just hold down the Shift key while selecting each symbol, then follow the steps above to edit their center points as though they were a single symbol.

Make sure you edit the center point in the first keyframe on your timeline. If your timeline is not already open, click on Window and then Timeline. This way, all subsequent keyframes will retain the same center point, which will avoid the "drifting" that can occur when an object is tweened between two keyframes with two different center point positions.

1

2

3

2. Skewing the leg

Let's concentrate on just one leg for now. In fact, turn all other layers off so that only one leg of your character is visible. This character's leg is a solid shape. It is not broken down into two or more sections. I wanted to keep it simple and felt that one shape was enough for this walk cycle. My first step is to turn on Onion Skin and create a second keyframe in frame 2. Here, I begin to make the leg walk by selecting it with the Free Transform tool and skewing its bottom edge in the opposite direction from which the character will be walking.

3. Adding rotation

I repeat this procedure for several more keyframes, using the Onion Skin feature to reference my previous keyframe positions. At this point, I also combine skewing with some subtle rotation. The important part of this portion of the walk cycle is to make sure the bottom of the foot stays along a consistent horizontal path. It might be useful to draw a horizontal guide to help you.

4

5

4. Adjusting the foot shape

As the leg starts to lift up off the ground, I create a new foot shape by duplicating the original symbol, renaming it, then editing it to reflect its new position. Since most of the weight is now toward the toe, I redraw the leg as seen in the image. This may seem like an insignificant detail, but in the grand scheme of things this level of detail adds a lot to the overall look and feel of the character's movements.

5. Reviewing your work

Play back your animation frequently as you work through the walk cycle. Concentrate on one leg at first, and try to get it "just right." Often, less is more; you may end up removing several frames, as the tendency is to create too much movement at first.

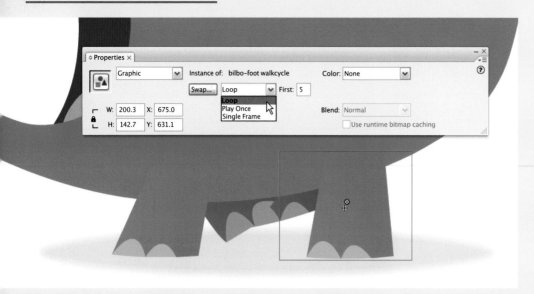

6A

6. Setting the walk cycle

When I feel the overall leg cycle loop is working, I go back to the parent timeline. This is the timeline that contains all of the character's symbols. I copy the symbol containing my leg animation and paste it three more times to create a total of four instances of the same leg. I delete the original three other legs at this point, as they are no longer needed. With enough frames inserted into my timeline, I can play back the animation and see all four legs "walking" simultaneously. They are all instances of the same symbol containing the nested animation, which means that my production output has been increased by 75% with this simple cut-and-paste.

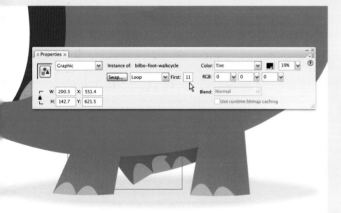

6B

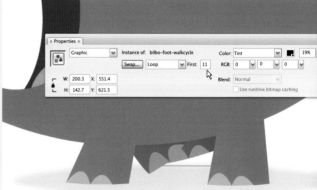

6C

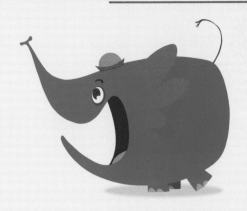

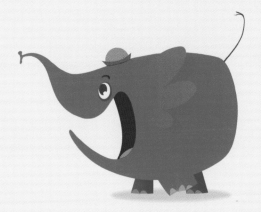

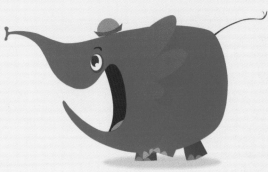

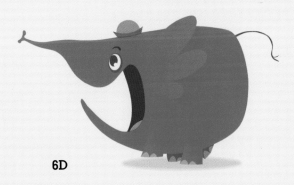

6D

However, my problem now is that all four legs are moving in sync with each other when their steps should be alternating. To remedy this, select one of the other Graphic symbol instances containing the leg animation. The Properties panel will update with options related to Graphic symbols. Use the drop-down menu to select Loop, and then type in a new frame number to change it from the default "1." This instance will now loop, but starting on the new frame number (see Fig 6A).

Repeat this procedure for the remaining two leg instances (see Figs 6B and 6C). For the Bilbo character, the leg instances start on frames 1, 5, 11, and 15 (see Fig 6D).

Artist profile: David B. Levy

Country of origin: USA
Primary areas: Shorts, television
Primary technique: 2D
URL: animondays.blogspot.com

1

David B. Levy is an award-winning independent filmmaker and animation director for Cartoon Network's [adult swim] series *Assy McGee*. Since joining the creative team at *Blue's Clues* in its first season, in 1997, he has mostly worked in preschool television. As *Blue's Clues* grew, Levy grew with it, transitioning from storyboards, to animation, and finally to directing the animation of more than 65 episodes.

Following *Blue's Clues*, Levy held supervisory roles on projects for Scholastic, The Disney Channel, HBO, and most recently the NOGGIN channel series *Pinky Dinky Doo*. He also served as the supervising animation director for the second season of the *Blue's Clues* spin-off, *Blue's Room*, and was also a consultant on the PBS Kids series, *Super Why!*

As an independent animator, Levy has completed five self-penned, award-winning films, some of which have been broadcast on television throughout the world. His most recent children's short, *Good Morning* (2007), has already been an official selection at the world's largest children's film festivals (among them Australia's Little Big Shots, The New York International Children's Film Festival, Chicago's International Children's Film Festival, Toronto's Sprockets International Film Festival for Children, and Brooklyn's BAMkids Film Festival). In addition to his animation work, in 2006 Levy became the published author of the first career book for animation artists in North America, *Your Career in Animation: How to Survive and Thrive*. He is currently working on a second book, this one about the ins and outs of animation pitching and development.

2

Levy has served as president of ASIFA-East (which is the New York chapter of a nonprofit international animation organization) since September 2000. He also regularly teaches animation at Parsons School of Design and The School of Visual Arts (SVA) and lectures at New York University, and Pratt Institute, all in New York City.

1–5. Stills from the short film *Good Morning*.

All images © 2007 David B. Levy

Good Morning

"In early 2007 I realized that I hadn't touched my brand-new Wacom Tablet, which was still sitting untouched inside its box," says Levy. "I decided to install it and maybe make a little film to test it out. Looking for inspiration, I searched through a stack of CDs and rediscovered a disc of children's songs written by my friend Bob Charde. He composed the theme to my first film, *Snow Business*. I popped on the CD and fell in love with a short song of his called "Good Morning." The tune was bouncy and full of joy. I made up my mind to animate to this track and, by evening's end, I had 14 seconds in the can. I finished the short over the next nine days."

3

4

5

Levy on the animator's education

I think the traditional skills of drawing, timing, and acting will be essential no matter where the technology takes us. Yet I think, at this point, it's a waste of time for students to have to shoot on film or go through that version of a traditional animation process. To do so would not prove useful in preparing students for a place in the current industry.

A traditional art foundation of drawing, painting, sculpture, design, etc., would be the beginning. Supplementing this would be acting, storytelling, and writing. The animation track would first teach the fundamentals or principles of animation, perhaps on paper and shooting on video lunchboxes. Next would be classes to translate the traditional information into animating on such programs as Adobe Flash, After Effects, and Maya. The last step would be the thesis or graduate film that pulls all the elements together. Oh, and of course, at least one class on legal issues and career strategy.

Nothing will ever beat on-the-job learning, not to take anything away from the school experience. For most students, there's something about having to justify your place in a studio, while working on a real job, which encourages learning at an accelerated rate. Jobs push you out of your individual comfort zone. On a job, you'll likely be asked to draw something or animate something that will take you to new territory. This ought to happen in school as well, but I think too much freedom is given to animation students. Freedom often allows students to rest on their laurels.

Working on *Good Morning* gave Levy permission to "bliss out." "Never had making a film felt so good," he says. Contributing to the fun were the filmmaking rules he assigned to this project. "Rules are incredibly important because they give you parameters on which to create," he says. "For a film that barely cracks the one-minute mark, it sure has a long list of rules. I decided to have no scene cuts and no separate backgrounds. There would be no other color. Overlapping lines between characters and backgrounds were okay. Instead of cuts, I used animated transitions between each scene. Forsaking a traditional storyboard, I deliberately worked straight ahead, allowing myself to paint the film into a corner at the end of each scene. I hoped this would all conspire to give the film a sense of joy and spontaneity. Certainly, with a track as good as Bob's song, I couldn't go too far off."

All the animation was created as brown line art against the texture of a brown paper bag. All the frames were drawn with the Wacom Pen right into Adobe Photoshop, then composited into Adobe After Effects, where Levy lined up the images to be in sync with the sound. "*Good Morning* was a paperless digital production, with the warmth of the handmade touch," says Levy.

Artist profile: Luke Feldman

Country of origin: Australia
Primary areas: Web, mobile media,
 Flash animation and interactives,
 festivals, games
Primary techniques: 2D, Adobe Flash
URL: skaffs.com

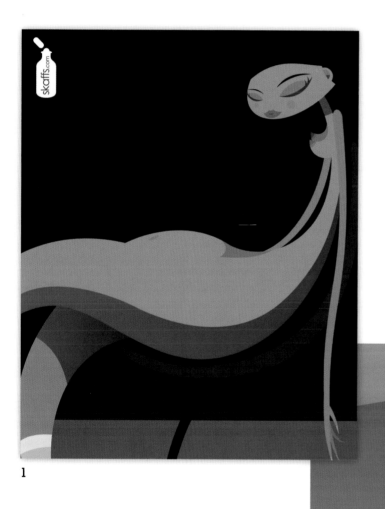

1

Luke Feldman, creator of SKAFFS (a collection of illustrations, fine art, animations, Flash interactive games, and other products), is an Australian artist who creates for a multitude of platforms. Inspired by childhood experiences and a vivid imagination, his illustrations and animations are minimalist, with defined lines, detailed characters (especially his whimsical females), and vibrant colors. He studied visual arts and multimedia in Australia, and has worked in the gaming and animation industries and the Department of Education. His work includes computer animation, Flash interactives, website design and functionality, character design, and advertising. While the scope of his work is extensive, it is bound together through his unique and dynamic style, which has led to a number of awards, exhibitions, and work with clients ranging from movie studios to soft-drink giants.

2

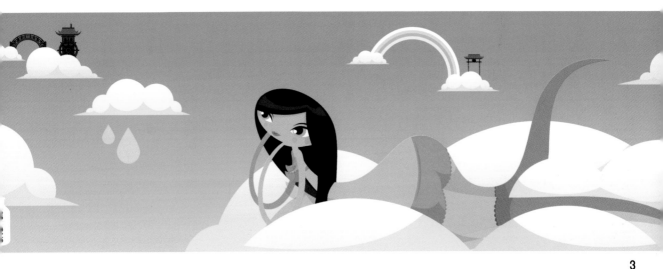

3

Some of the highlights include Flash animation and interactive content for Wallop, a social-networking company; illustrations for Coca-Cola's 2007 advertising campaign; designs for a one-story Macworld Conference booth, and fashion illustrations for Custo Barcelona. Feldman has been featured in *Desktop, Contagious, Staf, DPI Magazine*, and many other international magazines. He has exhibited worldwide, including a 2008 Los Angeles exhibition to mark the launch of the *Dr. Seuss' Horton Hears a Who!* film.

He was a finalist in the Erotic Art Prize, the Desktop Create Awards illustration competition, the Addicting Games Flash Game Design Competition, and the International Independent Film Festival at the 2007 Comic-Con International in San Diego. His SKAFFS product line includes popular skate decks, giant vinyl adhesives, T-shirts, and collectible toys.

Says Andrew Farago, manager and curator of the Cartoon Art Museum Gallery, "Luke Feldman's artwork blends the classic styling of 1950s Disney with a modern design sensibility to create something both cutting-edge and timeless."

Who Saved the Moon

One of Feldman's favorite SKAFFS characters is Berpunzel—a simple, yet lovable fellow who has nothing but the world's best interests at heart. "It was 2006 when I came up with the perfect animation storyline that would highlight the characteristics of Berpunzel," says Feldman. "Within a couple of weeks, I was able to story-board, animate, and compose the music for the final product."

Who Saved the Moon—a 1½-minute Flash animation in which Berpunzel stumbles across what appears to be the moon in trouble, and must come to its rescue—made its world debut at the 2007 Comic-Con International Independent Film Festival, where Feldman had the chance to speak. "It was an awesome experience to be able to present a project that I am so passionate about to the crowds," Feldman says. The short has since featured on multiple international film websites, including Channel Frederator, and also at the 2008 Little Big Shots Film Festival in Australia.

Once Feldman has an idea for an animation, he begins sketching the characters and loosely thinking about locations.

1. Still from *In the City*. This short animation captures the atmosphere of a balmy summer's night in a bustling city. Luke Feldman created all character design, animation, and music.

2. Still from *At the Beach*.

3. Still from *In the Clouds*. This short provided an opportunity for Feldman to incorporate his SKAFFS creatures with his whimsical females. Emiko represents Mother Nature as she creates cute characters to roam the world.

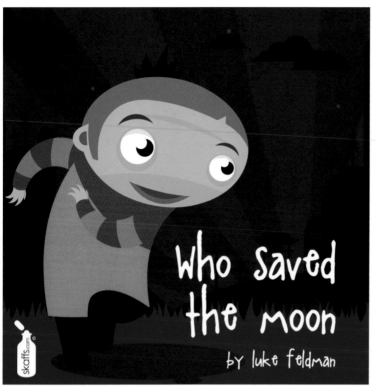

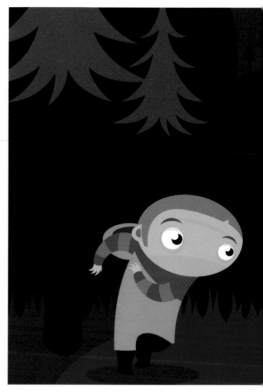

4

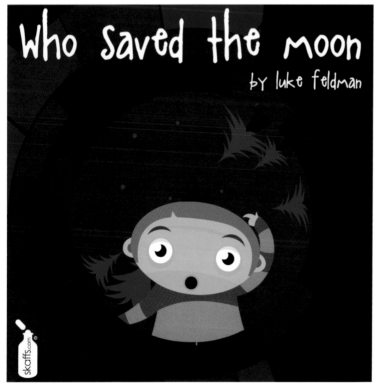

5

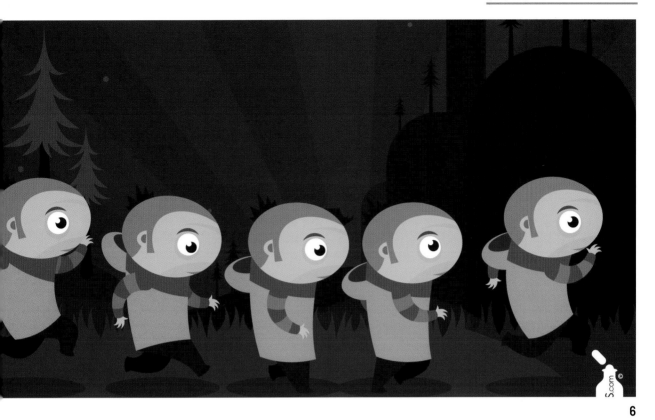

6

He creates character sheets that illustrate the character's personality and facial expressions. Once the story has been fleshed out, he develops the storyboards. Using a Canon flatbed scanner, he imports the storyboards into Adobe Flash or Adobe After Effects to create an animatic. The animatic is then exported as an AVI (audio-visual interleave) or QuickTime file, and imported into Flash. He then scans in and imports the character designs and animated sequences into Adobe Illustrator, and develops vectorized characters and backgrounds.

"After I have created all the illustrations and animated frames, I start laying down the animation. By this stage, I have an idea of what I'm doing with the sound effects and music," says Feldman. "The music is a combination of my guitar playing and digitally created music within Propellerhead Software's Reason or Adobe Soundbooth."

4 and 5. Stills from
Who Saved the Moon.

6 and 7. Sequences from
Who Saved the Moon.

*All Images © 2008
Luke Feldman*

7

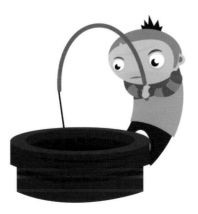
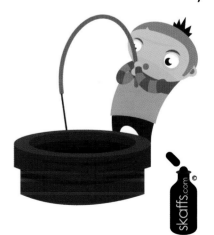

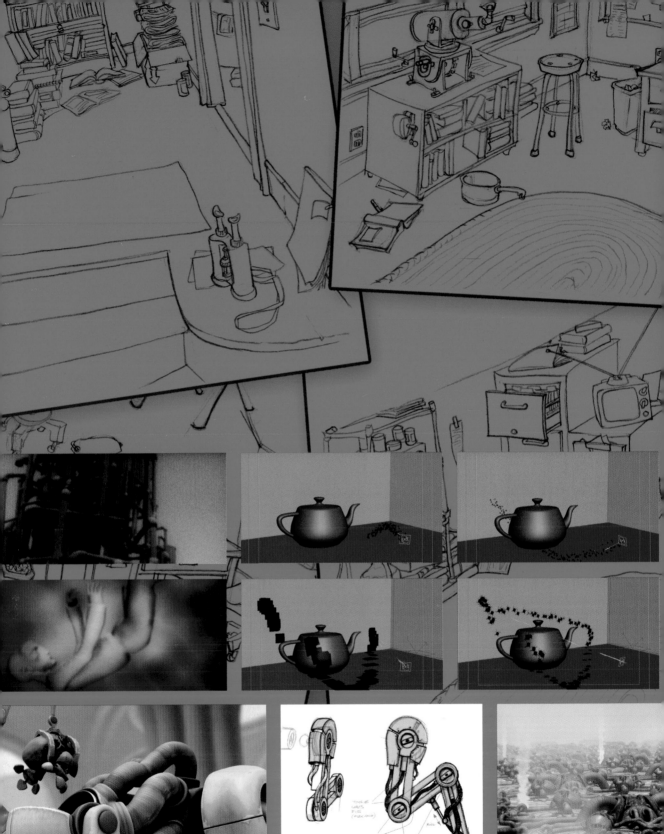
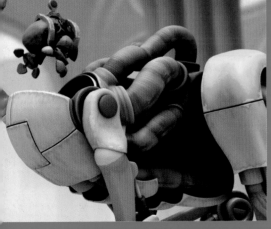
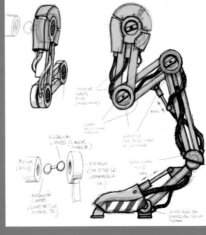

3 3D Animation

3D pipeline

1–4. Stills from US animator Dado Ramadani's 3D short film *Nereus*.

5. A preproduction sketch of the tower from *Nereus*.

6–8. Wireframe models at the stage of character rigging, by artist Steven James Taylor, for *Nereus*.

All images © 2008 Dado Ramadani

With each new animation project comes a unique set of choices in terms of content, style, and process. When digital 3D tools are involved, however, there are certain steps—a whole pipeline of them, in fact—that animators generally follow due to industry standards and 3D-specific technological requirements.

A "pipeline" is defined as the sequential production process of an animated film. In most cases, this means the channeling of animation assets through the main stages of production, including those outlined below.

1

Preproduction
Introduced in Section 1, this stage includes story, design, and previsualization.

Modeling
The process of developing a mathematical, **wireframe** representation of a 3D character via specialized software such as Maya or 3ds Max (both from Autodesk).

2

Rigging
The process of adding bones, constraints, and controls to a character or other articulated model to prepare it for animation.

Texturing
The process of adding surface characteristics to a 3D model. These textures may be composed of many individual layers.

3

Layout and animation
The stage of production in which character motion and camera moves are roughed out before finished animation is added.

Lighting and shading
As in photography and cinematography, effective and imaginative lighting—using virtual key, fill, and other types of lights; adjusting ambient light levels; and shading—can have a strong effect on the dramatic impact, informational clarity, and mood of a scene.

4

Rendering

The process of creating a 2D representation of a 3D scene. According to Steve and Raf Anzovin's excellent book *3D Toons* (Barron's Educational Series/The Ilex Press, 2005), "Rendering is the representation of a high-level object—a model—as an image for display. To accomplish this, the software requires a geometric description of the model and its surface qualities, a full description of the light sources and their light-scattering properties, and the location of an observer, that is, a camera view."

Compositing

The postproduction process of layering images or animations to create a final work of many combined elements. The case studies, workthroughs, and profiles that follow in this section will explore a few of the ways in which 3D artists adapt these processes to their own needs.

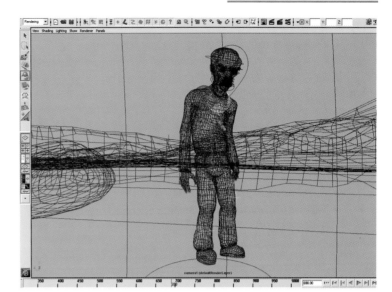

6

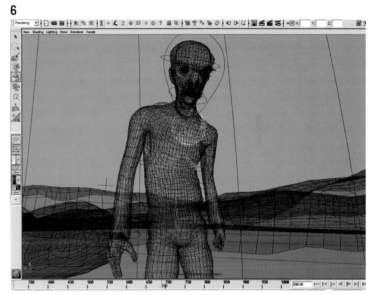

7

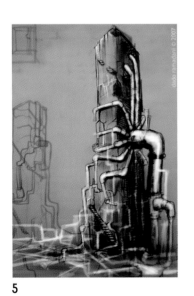

5

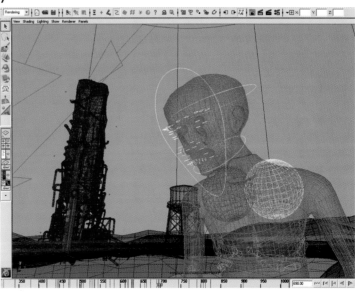

8

Case study: Creating Goobees

Goobees is a three-minute **CG** (computer graphics) short that was released online at goobeesFilm.com. It was created by Seth Freeman, Michael Losure, Patrick O'Brien, and Antonio P. Piedra, four former graduate students in the Visualization Sciences program at Texas A&M University.

The film playfully juxtaposes the lighthearted imagery of anthropomorphized candies against a morbidly humorous story of how the goo-filled, chocolate-covered candies are made. The film, its creators say, also remarks on the nature of human curiosity. When a child witnesses the peculiar candy-making process through a magical window in a vending machine, we watch the child's reaction to the grim spectacle, leaving us wondering, is he disturbed by what he has seen, or does he push the button for more candy and begin the process again?

The short was inspired in part by the "Colonel Sweeto" strip from Nicholas Gurewitch's comics series *Perry Bible Fellowship*. The team initially wanted to adapt the three-panel strip to make a short film, but to avoid legal issues they moved away from the strip's premise and came up with an original story. Other influences include the Sprite Animation Studios films *Journey to the West* and *Monster Samurai*, The Blackheart Gang's *The Tale of How*, the stop-motion films of Aardman Animations, and Tim Burton's *The Nightmare Before Christmas*. "We tried to create a simplified, handcrafted look, as though the objects were built as miniatures," Piedra says.

1–3. Various design ideas for the Creeps characters.

1

Primal drums beating, wind blowing, camera pans right across the war-hardened faces of the chocolate army.

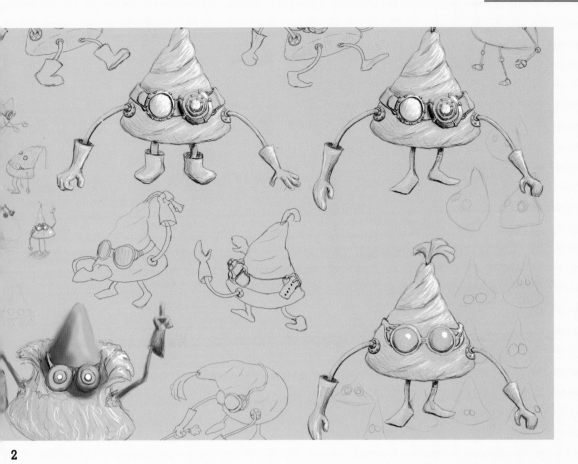

2

Team background

Freeman, Losure, O'Brien, and Piedra first joined forces in early 2006. Piedra was creating a set of 2D animations called "Interstitials," and the other three volunteered to help. After finishing "Interstitials," the four began preparing for a course through which industry professionals help students to make short animations. The team had several ideas, including the one that would become *Goobees*.

"Initially we played with the concept of chocolate candies versus colored candies," says O'Brien. "We talked about their war and its history. However, as we fleshed out the story, we developed the idea of the Creeps—chocolate drops–like characters that rule the candy land. We liked the idea of these mysterious, crazy characters and their sophisticated, but rustic factory. With the tinfoil and white goggles, they have a distinctly different feel from the other inhabitants of the candy world."

Team responsibilities

Seth Freeman was the lead character technical director (TD). He designed the majority of the rigs and provided technical support for rigging problems. He modeled and rigged the Chocolates, Gumdrops, Creeps, and machine parts in the factory. He also built a toolkit of interlocking factory pieces, such as the conveyor belts and goo pumps, that had **procedural animation** built into them. They were designed so that the set builder could simply tweak a speed or frequency value, and the rigs would take care of the rest. Freeman's kit saved the team a lot of time in animation and modeling.

Tony Piedra was the assistant character TD, lead set designer, and matte painter. He made the boy model and rig, and modeled most of the candy land. He created all the background and foreground mattes in the film, and the team took full advantage of his artistic abilities in the shots showing the outside of the factory/castle.

3

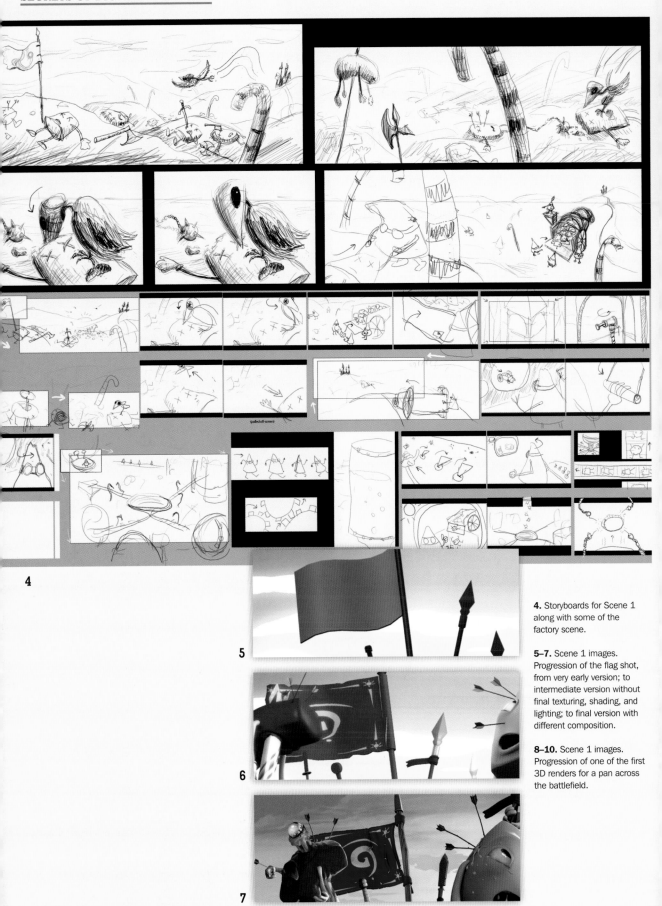

4

5

6

7

4. Storyboards for Scene 1 along with some of the factory scene.

5–7. Scene 1 images. Progression of the flag shot, from very early version; to intermediate version without final texturing, shading, and lighting; to final version with different composition.

8–10. Scene 1 images. Progression of one of the first 3D renders for a pan across the battlefield.

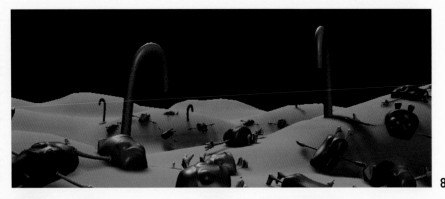

8

9

10

"Nothing in those shots is 3D except for the birds and the Creeps. The rest is matte painting!" Piedra says. This saved a tremendous amount of time in modeling and shading. Piedra and O'Brien also worked closely together in the factory scene, using foreground mattes to help provide indirect light in the scene.

Michael Losure was the lead editor, camera, and layout TD. He created previsualization models of all the scenes, did the camerawork, and was also in charge of the story reel from initial story-boarding all the way through to final edit. Losure helped with shading, creating key **shaders** such as the tinfoil for the Creep characters. He also did most of the animation in the film.

Patrick O'Brien was the lead lighting TD, responsible for lighting all the shots. He also helped with shading, providing shaders for most of the candy land and the factory. O'Brien used his past experience with rendering to help make the rendering and compositing process go smoothly. He wrote Maya Embedded Language (MEL) scripts to automate rendering passes and render setup. He also created several Shake networks for use in each shot's composites. Additional support came from Rodrigo Huerta, Eric Peden, Ozgur Gonen, Frederic Parke, and Greg Armstrong.

Tools and techniques

Goobees makes use of Maya 7.0, RenderMan (RenderMan Artist Tools and hand-coded shaders), Shake 4.1, Final Cut Pro, and Adobe Photoshop CS3. The film has several different environments, including an expansive battlefield and a huge, detailed factory filled with many characters and props. A variety of techniques were used to meet the challenges presented by the scale and scope of the project.

"To be honest," says Losure, "none of us want to be animators. We actually designed the film to have as little complicated character animation as possible, and tried to use as much procedural animation as we could. We designed the factory scenes to largely animate themselves using Seth Freeman's toolkit of interlocking factory pieces. For the two shots where gumdrops fall and bounce down a hill and through the factory pipes, we tied the gumdrop's body to a Maya rigid body simulator to get the overall body motion, and then hand-animated the flailing arm and leg to match."

The team made use of matte paintings in the background layers to add depth and parallax motion. Matte paintings also provided detail in the foreground layers. Because of limited resources and the computational costs of **global illumination** methods, they added indirect illumination through 2D painted light. They used Shake's motion tracking and color correction tools to integrate the 2D and 3D elements. "To further improve the lighting," O'Brien says, "we used a Shake script to keep ambient occlusion out of brightly lit areas. The script basically masked bright areas so that occlusion wouldn't be applied in the composites."

The characters in *Goobees* use cartoon rigs to perform exaggerated bend and stretch animations. Blendshapes are used to provide a wide range of facial expressions. (See the Glossary for definitions of CG-specific terms.)

11–13. Scene 1 images. Progression for a crane shot of the castle. The first shot has all 3D elements, while the final shot is a full 2D matte painting, except for the 3D birds and Creep character.

14 and 15. Scene 2 images. Pullout shot of one of the Creeps' machines, early and final. The final version has more saturated color.

13

11

12

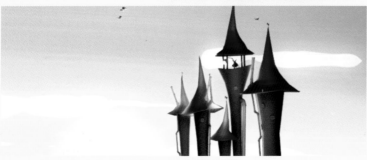

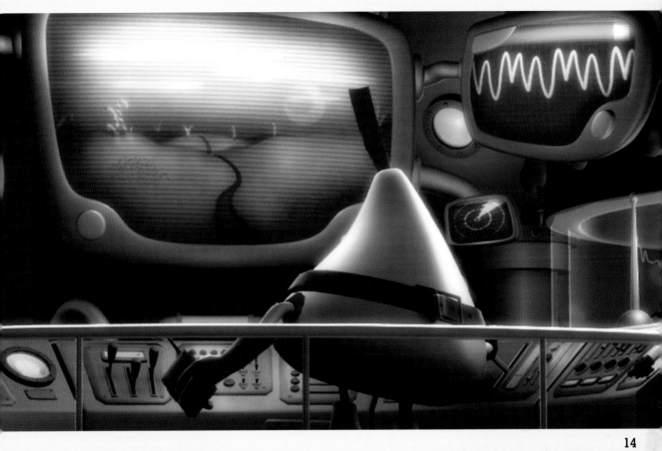

Creating believable characters

According to Piedra, there really is no character development in the film, so the believability of the characters is not so much derived from animation, but more from the character's overall design. "In terms of design," he says, "I don't think you can look at the characters separately from the world they inhabit. For our characters to be believable, the entire world needs to feel integrated, and to support the idea of the existence of these warring nations inside a vending machine."

From storyboard to finished product

The production was not exactly a smooth progression. Freeman admits that the team could have spent more time in preproduction nailing down the look of the film and the story animatic. Additionally, they made some production choices based on the academic calendar instead of what made the most sense for the production. The Texas A&M Viz Lab hosts a showcase of student work each spring, and to make the deadline they rushed out a rendered version of the piece even though they were only halfway through their production schedule.

The entire final scene, with numerous crowd shots of candy warriors waving weapons, was animated and put together by one team member over two sleepless days and nights. "That meant we wasted a lot of time doing quick lighting and rendering jobs that we had to scrap and redo later. On the plus side, though, it gave us something concrete to evaluate and use as a guide for our improvements during the second half of production," Losure notes.

16

17

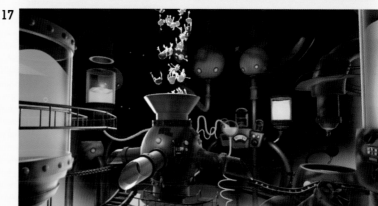

18

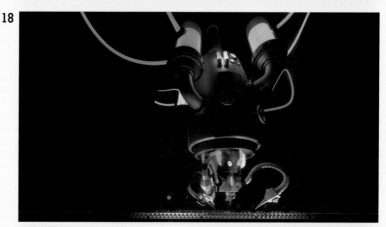

19

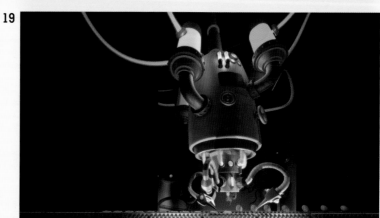

20

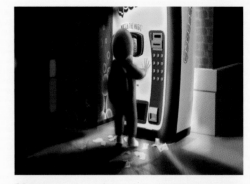

21

22

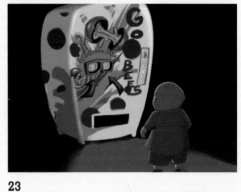

23

24

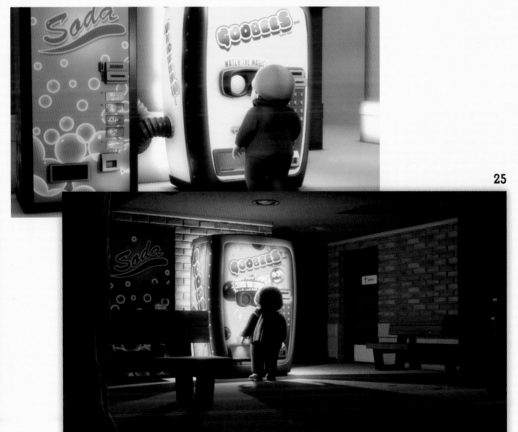

25

16 and 17. Scene 2 images. Wide shot of the giant sorting machine, early and final. The team felt this shot lacked depth, so they created several additional layers and added color shining up from the bottom of the shot to give the factory more life.

18 and 19. Scene 2 images. Shot of the goop injection machine, early and final. One of the few shots in the factory that didn't require a major overhaul in lighting.

20–23. Scene 3 images. Sequence of concept art for the boy, vending machine, and surrounding environment.

24 and 25. Scene 3 images. Shot of the boy, early and final.

26 and 27. Scene 4 images. Shot of the Chocolate army, early and final.

28–31. Scene 4 images. Both sides engage in battle, long shot and close-up, early and final.

All images © 2008 by Seth Freeman, Michael Losure, Patrick O'Brien, and Antonio P. Piedra

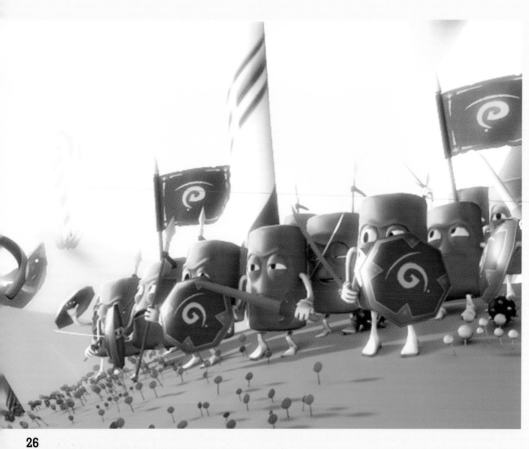

26

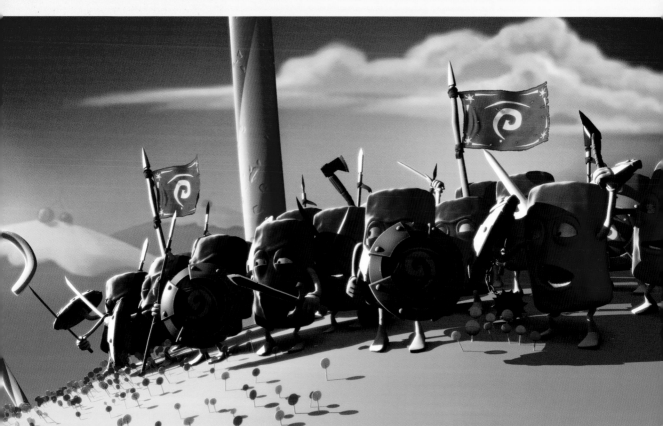

27

28

The budget

Unlike most projects of this type and complexity, *Goobees* had no budget. When making the film, all members of the team were enrolled at Texas A&M and allowed to use Viz Lab equipment. Especially helpful was access to the Lab's **render farm**.

Lessons learned

Freeman advises student animators to keep their films short and stick to one or two environments. Also, allotting time to fully develop the art direction and story is critical and often overlooked, he says. "It pays off to first storyboard, create color scripts, and develop concept art. We would have finished more quickly if we had taken more time in preproduction."

Losure adds, "You want to be able to know exactly what assets you need for the film, and just go out and execute your vision in production without having to redesign anything."

29

The future

"As with any project, you hope it will be well received. However, we all are a little shocked at how well *Goobees* has been received by both the graphics community and the general public," Freeman concludes. "Recently, we were accepted into the SIGGRAPH 2008 Computer Animation Festival, and we're also featured in *3D World* magazine's "Show Reel" section (issue 104). The entire team is honored to be able to participate in both."

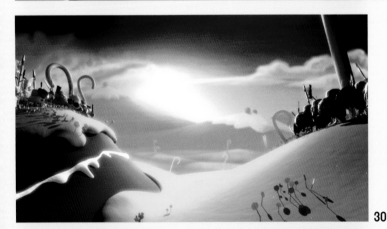

30

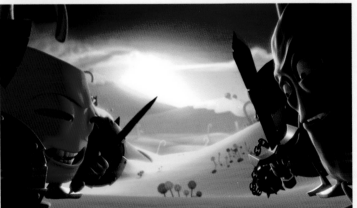

31

Skill profile: Short films of Chris Myers and Ken Seward

Chris Myers

Chris Myers (chrismyers3d.com) received his BFA in graphic design from the Art Academy of Cincinnati, USA, in 1999. For his undergraduate thesis he created his first film, *Echoes of Surrilicus*, a two-minute short involving a *Ben Hur*-style chariot race with a very different take on the chariots and drivers. "Timing was everything," Myers says, "and after one interview I had my first full-time animation job, two weeks before graduation."

Over the next four years, Myers worked as an animation/new media designer at Architechnology, Inc. in Cincinnati, Ohio. While focusing on animation, he also had the opportunity to work on lighting and texturing on most of the company's projects. The team won a silver and two gold AXIEM Awards for Absolute Excellence in Electronic Animation. The final project Myers worked on was a large 3D animation of the United States' proposal for a new Panama Canal, which the Army Corps of Engineers presented to the President of Panama.

Back to school

Myers then returned to school and received an MFA in animation from the Savannah College of Art and Design (SCAD) in late 2007. After going to school full-time for his first year, he took a job with SCAD as a full-time motion-graphics artist, and finished his degree part-time. During this time he codirected and was animation director on another short film, *Solomon Grundy*, based on the nursery rhyme of the same name.

"The film was completed in the graduate 3D collaborative class at SCAD, and we were very excited when our first festival acceptance was the 2006 SIGGRAPH Animation Theater,"

says Myers. *Solomon Grundy* also went on to screen at festivals in Japan, the Czech Republic, Italy, the UK, Poland, Brazil, Bosnia, and Hungary. It was then featured in a nationwide Hewlett-Packard print ad, and codirectors Ken Seward and Myers were featured in the January 2007 issue of *Computer Graphics World*. Tantalis Films in Paris now distributes *Solomon Grundy* to TV channels and other media internationally.

While often working with other collaborators, and in different genres of animation, the core of Myers' artistic influences has remained the same. "Comic books have been one of the most consistent themes in my life," he says. "Where else can you find 22 pages of key poses for inspiration? Their influence has led to a natural progression to Pop Art and bold colors that juxtapose my love of 'steampunk' science fiction and the Victorian era. I grew up on Looney Tunes and classic Disney cartoons and love to try and push the digital rigs into poses that were not possible five years ago. Animations that excite me the most are ones that make you question what medium they were completed in. Was that digital? Let's watch it again!"

After finishing school, Myers worked briefly as a motion-graphics artist, in Savannah, Georgia, while working off-site for Walsh Family Media's 15-minute film, *The Cool Beans: We Need a Hit*. He is now finishing his graduate thesis film, *The Truth Teller*, which will hit the festival circuit in early 2009. He currently works as a character animator at Activision/Neversoft in Los Angeles, on the *Guitar Hero* franchise.

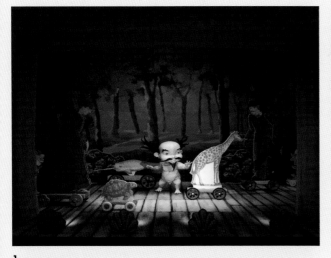

1

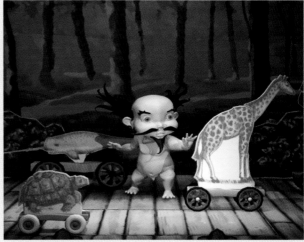

2

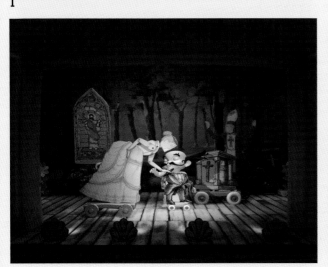

3

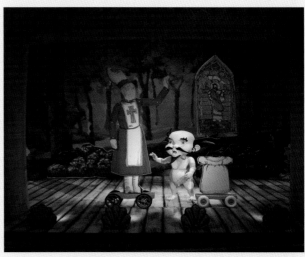

4

1–5. Preproduction sketches and production stills from *Solomon Grundy* (2006).

5

6

Creative process

"I use Autodesk Maya for the bulk of my animation, but nothing starts without my trusty pencil," says Myers. "In the early stages I like to do everything on paper so I know just what to expect when I take it to the computer." This ranges from concept sketches to color palettes and animation thumbnails. He often has his 2D light board set up beside his computer so that he can spin around and sketch out ideas as he goes. "When time permits, I also really enjoy doing a physical character maquette out of Roma Plastilina Clay. I use Adobe Photoshop for most of my texturing, and somewhere along the line Adobe After Effects always comes into play."

Collaboration and regular input from friends and colleagues are essential to Myers. "In some cases I have given them a document that describes an environment and they have sketched it out. Others have helped with everything from texturing, lighting, or just bouncing story ideas off of them to see what sticks. On some shorts, such as *Solomon Grundy*, there were six of us collaborating, and also a codirector. In my current film, *The Truth Teller*, I get to make all the final calls, but still count on a lot of input and help."

While he enjoys working on the entire process—from developing the story and designing the characters to desaturating the final output—Myers has also jumped on board halfway through and focused solely on character animation. "Following another director's lead is also very rewarding, and it can be so much fun to just animate for a while. I really enjoy having my hand in both areas and often jump back and forth between working on my own films and working toward someone else's vision."

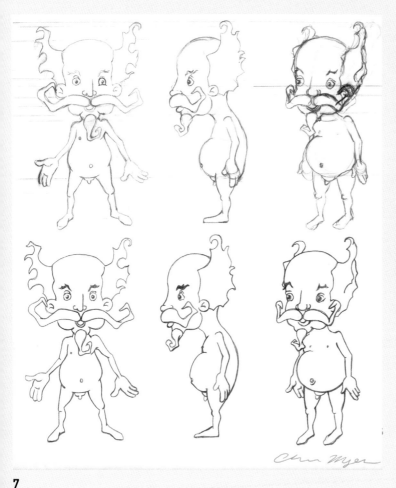

7

Solomon Grundy team

* **Codirectors:** Ken Seward and Chris Myers
* **Producer:** Natalie Moore
* **Animation Director:** Chris Myers
* **Art/Concept Director:** Ken Seward
* **Texturing Director:** Joshua Muntain
* **Lighting Director:** Jen-Feng Tsai
* **Pipeline Manager:** Suresh Narayanasami

6 and 7. Preproduction sketches from *Solomon Grundy* (2006).

Ken Seward

Solomon Grundy codirector Ken Seward grew up in Las Vegas, and his background is mostly in botany and chemistry. He worked as a clinical and forensic toxicologist before deciding to go back to school and focus on art. "I've always been fascinated with animation, especially the stop-motion variety, such as stuff by Janie Geiser and the Brothers Quay," he says.

Myers and Seward met the summer before their collaborative animation class at Savannah College of Art and Design. They pitched the *Solomon Grundy* idea to the class, having already created an animatic for the film over the summer, and "hit the ground running" when class started.

"For my part," says Seward, "I've always been interested in fairy tales and nursery rhymes, and *Solomon Grundy* had been a favorite of mine since childhood. I always liked its dark humor. Surprisingly, most of the others in the class weren't familiar with the rhyme, so it took a bit of explanation." While Myers was the animation director, Seward was the director in charge of overall design, which meant "occasional fights over whether or not to move the camera or what color things should be … how the models should look."

Many other class members contributed some actual animation time. Joshua Muntain and Seward built most of the stage and props. Solomon himself was built by the lighting director Jen-Feng Tsai, who had never modeled a character before.

"It was a great class," Seward concludes. "We all learned a lot about working in a group … and about the kind of dedication that's involved in pulling off even a very short piece of animation. Our class was unusually small for the collaborative project class, but we managed to get it done and on time because everyone really pitched in and did whatever it took."

Workthrough: Chris Myers on the 3D animation workflow

Here Chris Myers walks us through the early stages in creating his short 3D film *The Truth Teller* (2009). About the film Myers says, "Telling the truth can be harder than you think. Conspiracy theorist Friedhelm Norbert Nacht struggles to get the truth to the masses. In my new short film, we watch Friedhelm create a new episode of his video blog, The Historical Truth. It is very important that he tell the world that it was the Masons who created The Great Seal of America."

1. The script

When creating your own short animation, it is important to review the script before animating each scene. Scripts are often organic and can change throughout the production. You need to understand what is happening on both ends of the shot and be sure not to steal the thunder from another scene that may actually be the crescendo of that particular act in your film.

2. Voice recording

On many productions you may not be doing voice acting, but when creating your own short film, you are often either a voice actor or directing your friends. Take time to get into character, and remember that your shot needs to fall into place within the entire short.

1

2

3

4

3. Voice tempo brainstorming

Whether you did the voice acting or not, you now need to listen to it and study the beats in the dialogue. I like to write the dialogue down, add notes, and draw early thumbnails. This will allow you to think about what is happening in a pause or exactly when your character takes a breath, and most importantly, to follow the rhythm of the shot and add finesse.

4. Thumbnails

At this point, I not only know what the goal of the shot is, I also have a good understanding of the dialogue, and I know what words I want to focus on in the voice track. I like to continue acting it out while finalizing thumbnails that pin down all the actions, and I often write down my initial thoughts on the number of frames between poses. This is where 90% of the shot is decided, and the final paper is a blueprint of the animation.

5

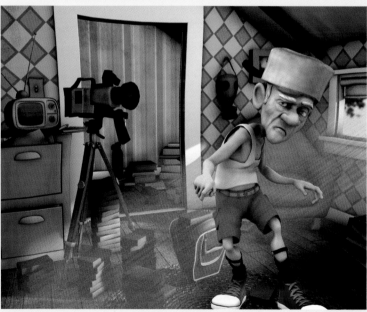

6

5. Video reference

Based on my blueprint, I now use a tripod and set up a video camera to record reference footage. When possible, I set the camera up with a mirror behind it so that I can really see how I am moving. I hit Record and let it roll while I act it out numerous times, then edit the best parts together, and often put a grid over the final version.

6. 3D program

I now have my blueprint with clear thumbnails and frame numbers written down, along with a reference video. It's time to take the animation into the computer.

Workthrough: Chris Myers on creating a 3D environment

Here Chris Myers walks us through his process for creating the main environment, the den, for his 3D short film *The Truth Teller* (2009).

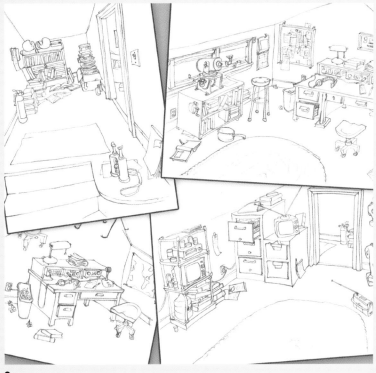

1

2

1. Character biography

One of the first things I like to do is create a character biography. Friedhelm's is 22 pages long and covers everything from his spiritual beliefs to his favorite foods to when his parents emigrated from Germany. This not only allows you to know how your character will react to any situation, it also gives others on the project an insight into your character.

2. Design drawings

Designer Josh Muntain read through Friedhelm's biography and, after some discussion with me, created Friedhelm's den. Knowing Friedhelm's background gave Josh the insight he needed.

3

4

3. Modeling

Armed with Josh's drawings, Ken Seward and I modeled the den using **polygons** and non-uniform rational B-spline (NURBS).

4. Texturing

One of my main goals was for the film to look as original as possible, and I have always been heavily influenced by stop-motion films. With this in mind, Ken and I began to texture Friedhelm's environment, giving the cartoon angles a more realistic stop-motion approach.

5

6

5. Lighting

I created three different color palettes to match the emotion of the scene and to coincide with Friedhelm's struggle to get the truth to the masses. With detailed script notes and two years' worth of lighting examples that I had collected or created, I completed the lighting.

6. Final render

The struggle to get the final render just right can be extremely tough, but as you wrestle with the look you have envisioned, it can also be really exciting. I like to render in as many layers as possible to allow for touch-ups and further manipulation in postproduction.

*All images © 2008
Chris Myers*

83

Workthrough: Tyson Ibele on effects animation

1

In this tutorial, we'll be using Particle Flow (pFlow; a nonlinear, event-driven particle system developed by Oleg Bayborodin as one of Autodesk 3ds Max's seven particle emitters) to create a particle system that is able to fire bullets and hit objects (blowing off debris) while leaving marks on the objects that are hit. This technique was put into practice in my short film *Cycle Down*, and though it is simple, I believe it would work in any production environment.

1. The scene setup

The first step is putting together the scene that forms the context for the system. If you incorporate this particle effect into any of your own projects, the geometry you use will undoubtedly be more complex, but it's best to start off with a simple scene. Here we'll be using a floor, a wall, and a teapot. The exact setup is shown in Fig 1.

Tyson Ibele

A self-taught animator born in Canada, Tyson Ibele (tysonibele.com) has worked in the animation industry for more than five years, beginning his career as an amateur freelancer while still in high school. He now lives in Wellington, New Zealand, where he is studying film while working as a lead animator and visual effects artist for US-based studio MAKE (makevisual.com), where he creates advertisements for television and other media outlets.

"I firmly believe that, with enough practice, anybody can become good at digital animation—so long as they have the passion for it," says Ibele. "I've always thrived on the creativity that animation allows me to express and hope that I can pass on some of that desire to other up-and-coming animators."

All images © 2008 Tyson Ibele

2

2. The particle system

We'll pretend that the teapot is about to be shot by a firing squad, so we'll place our particle system in front of it. We'll also scale down the particle system so that the stream of "bullets" is narrow, as if being fired from a gun. I added some rotational keys to the particle emitter so that the stream of bullets hits a good range of surfaces. You'll see this illustrated in the following series of images, where I set the start range of the system to 0, the end to 100, and the total number of particles to 1,000.

Of course, rather than shooting a stream of breathtakingly scary bullets, we've got a noodley stream of fairy dust. Now we begin the process of really getting this scene to look effective. There will be three main parts to our pFlow: the bullets, the impacts, and the marks left by the impacts.

So, step one is to speed up our particles. Instead of the default speed of 300, change the speed to 3,000 (and set the variation to 1,000). We'll also decrease the number of particles to 200.

3. The pFlow event

Next, we'll set the Particle Display Mode to Geometry so that we can see the actual particles and set their rotation to Speed Space Follow. This will cause the particles to orient themselves in their direction of travel. After doing this, we'll add a scale operator to the main pFlow event and set the scale to 180, 2, and 2 for the X, Y, and Z values, respectively. You may need to adjust those values to fit your scene, depending on your scene's overall scale. Basically, the idea is to have your particles looking like long, thin streaks (i.e., how a bullet would look traveling through the air very quickly, if you could see it). Your main pFlow event should now look as shown in Fig 3A, and your pFlow (in the viewport) should look roughly as shown in Fig 3B.

We don't want black bullets, though, so we'll add a Material Static operator to the main event and give it a material that's yellow and fully luminous. That'll make our bullet streaks look more like hot metal streaks (similar to the effect that might be seen in many video games when an automatic weapon is fired and the bullet streaks become visible).

3A

Event 01

Birth 01 (0-100 T:200)

Position Icon 01 (Volume)

Speed 01 (Along Icon Arrow)

Rotation 01 (Speed Follow)

Shape 01 (Tetra)

Scale 01 (Overwrite Once)

Display 01 (Geometry)

4. Setting up the impact hits

So, now we're ready to set up the impact hits. At the moment our particles go right through the geometry, and that's obviously no good. What we need is a set of Collision Tests. We're using multiple objects in our scene, so a single collider won't suffice. Instead, we'll create two regular planar deflectors and align them with our floor and wall, and create a UDeflector for our teapot. We'll also set the bounce for all the deflectors to 0.2 and the friction to 66%. Don't forget to set the teapot as the Collider object within the UDeflector's settings!

Next we're going to add three Collision Tests to our main event. We'll add three because we need pFlow to distinguish between which object was hit, based on how we'll set up our marking system. So, add three Collision Tests and put a different Collision object in each one. (You should have three Collision objects: the two deflectors for the floor and wall, and the UDeflector for the teapot.)

Once that is done, create a new Spawn event and click the Delete Parent option, then add a Speed operator to the event and set the speed to Zero. Next, add a Shape Mark operator to the event, and finally, set the display setting of the event to Geometry. Your setup should now look like that shown in Fig 4.

3B

5. Final setup for impact hits

Now, you'll want to duplicate the latest Spawn event twice, then link each Collision Test to a different Spawn event. Then, within each of the Spawn event's settings, set each Shape Mark operator to point to whichever object its Collision Test is detecting. For example, the Collision Test that contains the floor deflector should point to a Spawn event whose Shape Mark operator points to the Floor object. The final setup should look as shown in Fig 5A.

4

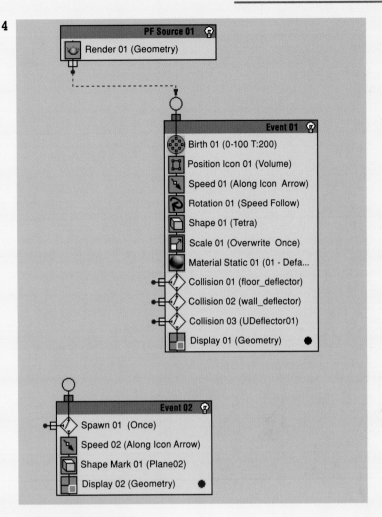

5A

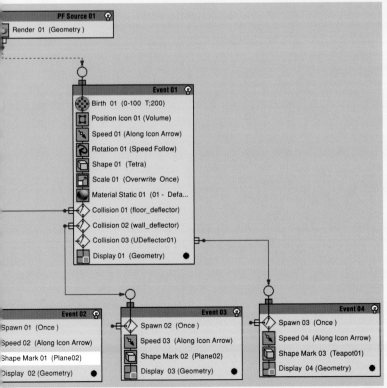

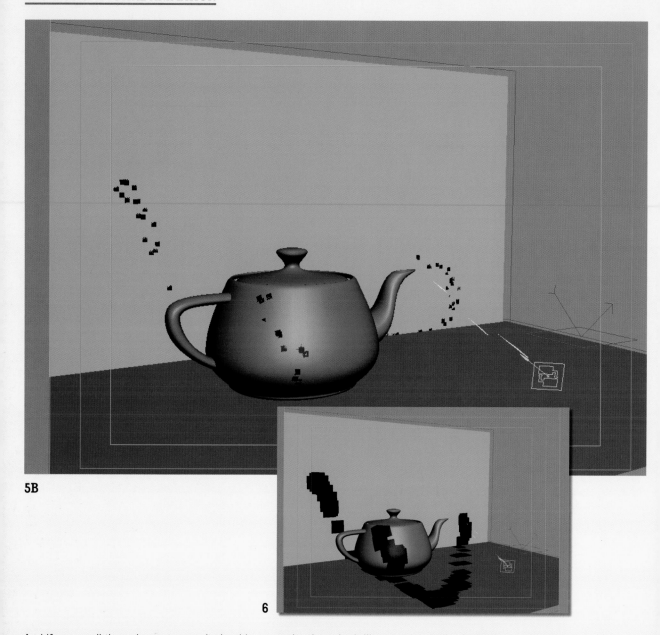

5B

6

And if you scroll through your scene, it should look like the one shown in Fig 5B. (NB: I set the display color of each Spawn event to black so that the effect is more noticeable.)

6. Working on the impact texture
Notice how, as our bullets fire at the surfaces of the objects, they leave little marks where they hit? This is the effect we want. The problem is that our marks are very small right now, and they are square. We are going to scale them up and give them a texture to make them look like genuine bullet-impact holes. To scale them up, adjust their length/ width values in the Options palette. I changed mine to 12, but you might need higher or lower values depending on your scene scale. (This is the case with all other scene-scale dependent variables as well.) Also, to avoid having the larger marks protrude from the surface of the teapot with jagged edges, I changed the Shape Mark operator setting for the teapot's Spawn event to Box Intersection. The result is shown in Fig 6.

7. Creating a decal texture

Now it's really starting to get interesting. That being said, these ugly boxes aren't very appealing, so we'll modify them to look more like bullet-impact decals. First, we'll create a simple decal texture in our image-painting application of choice. I used Adobe Photoshop.

8. Texture and material operators in place

You can also download a bullet-impact texture, instead of painting one—Google for textures that already exist. Next we'll create a new material in 3ds Max using the bullet-impact image as the **map** in the Material's Opacity channel. Then we'll add a Material Static operator to each of the Spawn events, and add this Material to each of those Material operators. By going back into the Material editor and making sure our Material is set to appear in the viewpoint, we'll be able to see the effect directly.

7

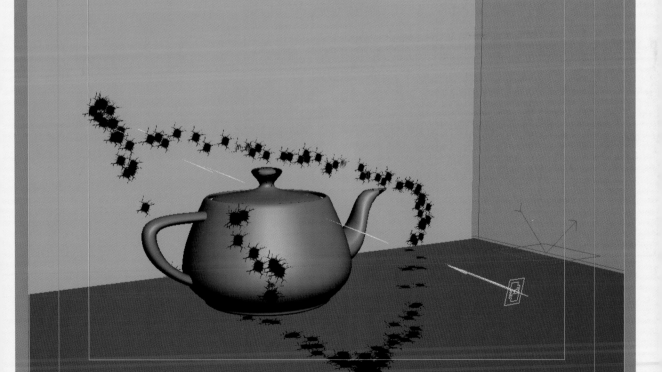

8

9. Creating debris

Now it's starting to look good. We've got our bullets and our impact decals; all we need is our debris. It's important to note, before moving on to the debris, that our decals are very repetitive at the moment because only one texture is being used. This can easily be solved by creating a series of different impact textures, then using a Material Frequency operator in our events to cycle through the different textures for each mark.

Our final step is to add the little debris that will fly off at each bullet hit. To begin, we'll start by adding a new Spawn Test into each of the Spawn events. To save time setting it up, you can add a Spawn Test to the first event, then paste an instanced version of it into the other two events.

We'll then create a new event to contain the debris. Do this by dragging a new Collision Test into the pFlow work area (which will create a new event), then link all three of the new Spawn Tests to that Collision event. Your setup should now look as shown in Fig 9.

10. Fine-tuning

If you play your video back in the viewpoint, you'll notice that you get a lot of new particles bouncing off in all directions. Although the new particles are good, the bouncing around in all directions is bad. We'll remedy this by adding a Gravity Space Warp to our scene and then adding a Force operator to the newest Collision event (after which we'll add the Gravity Space Warp to that Force operator), and finally we'll add all of our Collision objects to the Collision Test within the event and set the Collision Test to stop the particles after they bounce three times. Boy, that was a mouthful, but it's fairly simple to set up.

If you do that and play back the timeline (it'll be slow, and you might want to make a preview instead as there's a lot of collision testing going on now) it'll look a bit better, but there are still a few issues. The first is that some of the particles are still flying all over the place. The second is that each impact only spawns one debris particle.

9

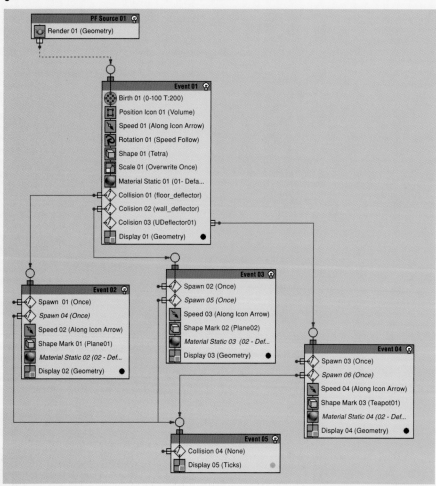

To fix the first problem, we'll go into the settings of the Spawn Test (the one we instanced between the three Spawn events) and set the inherited speed to 0. Then we'll add a speed operator to our Collision event and set the speed direction to Random, and the speed value to 200 with a variation of 100. (If the slow viewport previews are too aggravating, you can turn off the Collision Test in the Collision event for now.)

To fix the other problem, we'll go to the settings within the instanced Spawn Test and change the offspring to 10. Now each impact will spawn 10 debris particles. Figure 10 shows roughly what the scene looks like now.

11. Grouping chunky shapes
Now we basically have the entire framework for our debris particles set up. The only things left to add are a Shape Instance operator, which will instance premade debris geometry (to give the particles a chunky shape), and a Spin operator so that they spin through the air as they fly off the objects.

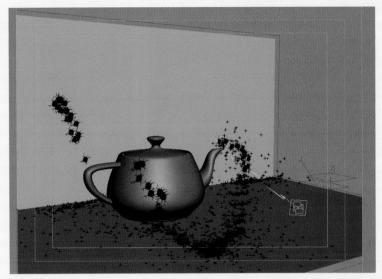

10

11A

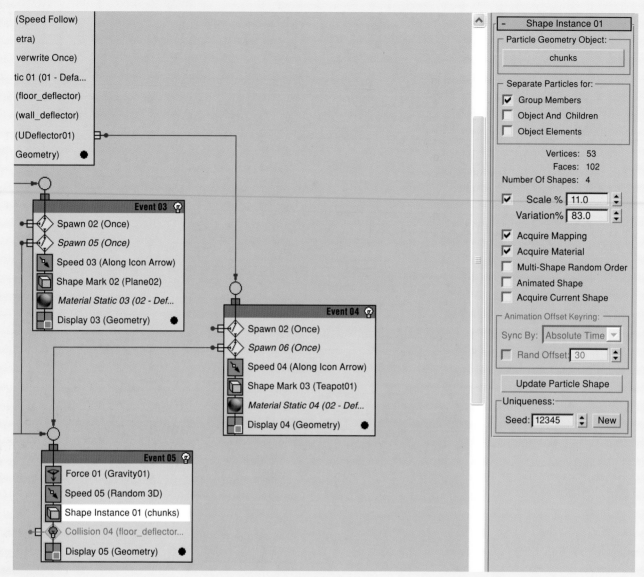

11B

To instance some chunky geometry we'll first create some chunky shapes and group them together as shown in Fig 11A.

It's important to note that "group them together" wasn't a figure of speech here: you need to make sure they're actually grouped using the Group command from the Group menu. Next, add a Shape Instance operator to the Collision event, select the new geometry group, and click the Group Members option. This will assign a random member of this group of chunks to each geometry particle. Finally, set the scale of the instanced geometry to match your scene. You probably want very small debris chunks with the variation value set relatively high. Once again, the scene may move slowly right now if you've got the Collision Test turned on, so you can keep it off for now (see Fig 11B).

12. The final event

Next we'll add our Spin operator to the event and give it a value of 1,200 with a variation of 600. This will give our particles a nice, fast spin. However, they currently all start off with the same orientation, so we'll also throw in a Rotation operator and set the initial orientation to random.

We're almost done; the only thing left is to prevent the particles from spinning after they've come to a stop. You'll notice that if you turn your Collision Test on (or if you already had it on), the particles keep spinning after they stop moving on the ground. To fix this, make a new event containing a Spin operator, set the Spin value to 0, then link the Collision Test from the Collision event to this new Spin event. Also, add a Rotation operator to the Spin event and set

the orientation to Random Horizontal. This will randomize the orientation of our stopped particles, but keep them flat on the ground (see Figs 12A and 12B).

So now we've got bullets, we've got impact decals, and we've got debris! And that basically concludes this tutorial. Of course, as you may notice, there are no textures on anything, nor is there an actual gun or a realistic scene. These are all things you'll want to add on your own, but otherwise, this is all the setup you need to create a compact particle system that will give you a cool bullets-hitting-and-damaging-objects effect! Once sound effects and proper lighting are added you'll have a really effective scene on your hands. Other effects (generated by more Spawn events) could also be added, like smoke that emits from the impact areas, or dust hits on the ground, etc. The sky's the limit.

12A

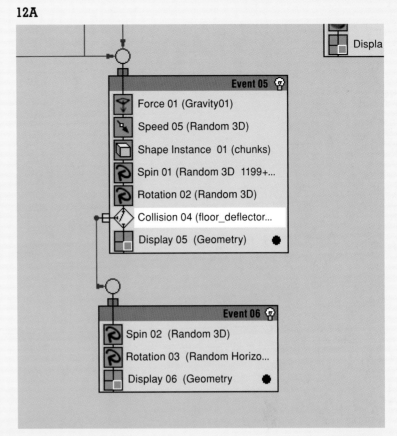

12B

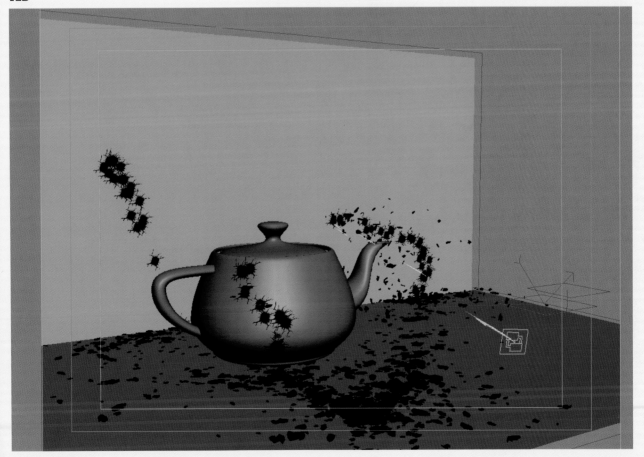

Artist profile:
JD van der Merwe

Country of origin: South Africa (now living
 in UK)
Primary area: 3D
Primary technique: Character animation
 in a wide range of media
URL: aserash.com

"As a South African animator living and working in the UK, I see a country that thrives on individualism and creativity, and does it in a way not found anywhere else in the world," says JD van der Merwe. "I've chosen to stay because here you can really be creative and make a name for yourself, even without a huge budget. The UK wedges itself nicely between the sometimes overproduced glamour of the US and the independent, sometimes experimental leanings of the European industry. It's a middle ground I feel most comfortable in."

In 2006, van der Merwe graduated from the London College of Music and Media (Thames Valley University), but he has worked as a 3D artist since before then, freelancing for several companies including Artem Digital, Zone Vision,

1

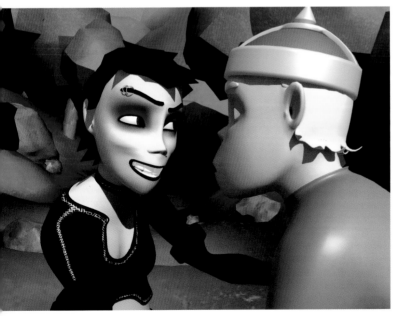

2

Payne-Halt Productions, and Angry Fingers. He has since taught part-time at his alma mater, and now specializes in characters, from modeling through texturing, rigging/setup, and animation, as well as hard-surface modeling. He generally uses Autodesk Maya for most of the pipeline, along with Adobe Photoshop, and sometimes Corel Paint Shop Pro for textures, Autodesk Mudbox for detailing, and Adobe After Effects and Adobe Premiere for compositing and postproduction.

His work has appeared on the Zone Horror channel in the UK and Zone Fantasy in Italy, and on the web as part of the Volkswagen UK website. One of his projects was even made into a giant animatronic National Football League (NFL) player for the NFL promotion in Trafalgar Square, London.

3

4

On South African animation

Unable to find work in South Africa due to a general shortage of jobs in the creative industries, van der Merwe immigrated to the UK, along with his parents. "South Africa has an almost negligibly small animation industry, and, even though I was also a fully qualified and experienced programmer, jobs were simply nonexistent."

He notes a relatively strong cultural difference between the two countries, but it's more pronounced from the perspective of a creative person. "The UK is a very creative and individual place where artists are respected and encouraged. In South Africa, the focus is much more on practical skills and rugged, macho pursuits. It's also a place where you are expected to fit into very specific categories—boxes, if you will. As an artist, I always felt out of place and unappreciated there."

According to van der Merwe, there are actually not too many places in the world where animators can bet on getting work. "The US is still the strongest animation industry, with Canada, Japan, New Zealand, and the UK coming in second, but the rest of Europe is developing quickly."

"I have made a life here in Britain," he says. "I married a British-Greek-Cypriot and bought a house not long ago. As beautiful a country as South Africa is, I can't see myself ever wanting to go back."

1. Boril, a character created for future animation projects and experimental purposes.

2. Still from a university animation project.

3. A "steampunk" submarine created for a future animation project and hard-surface modeling practice.

4. Tio, a character created for a forthcoming animation project. Initial concept by Richard Bawden.

All Images © 2008 JD van der Merwe

Workthrough: JD van der Merwe on realistic human modeling

1. Basic model

For this image I wanted to get as close as I could to a realistic representation of my wife Chrissy's actual face. I started with a face-on and profile photo of her head, and built the basic geometry to fit them. There are many resources online and in books explaining how to do this (see Reference guide, pages 166–167), so I won't go into detail about it. Once I was happy with the basic shape and edge flow of the model, I projected the face-on photo over the model to make sure that everything was actually in the right place. This also gave me the first indication of how the image would look when it was finished.

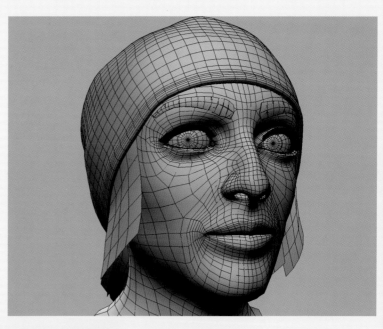

1

2. Color texture map

When I was satisfied with that, I sorted the texture coordinates by unwrapping the UVs (points on a polygon that are used by Maya to map a texture onto the polygon) so that I could take the model into Mudbox and create a displacement map. (However, I later decided not to use a displacement map, as there simply were not enough wrinkles and bumps to warrant the extra render time.) For a texture, I painted a 4,000 × 3,200–pixel texture map, with upward of 10 layers, in Adobe Photoshop.

2

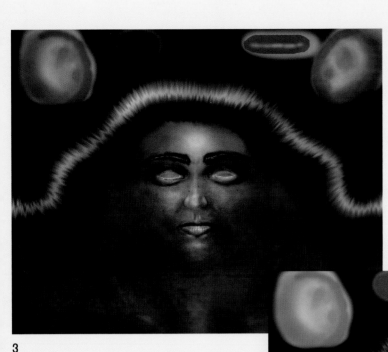

3

3. Specular texture map

I then adapted that texture and painted over it to create a specular (highlight due to light source) map, adding layer after layer of scattered spots where the skin is more oily and reflective.

4

4. Bump map

I also used grayscale variants with different elements accentuated for the bump and diffuse (light absorption) maps.

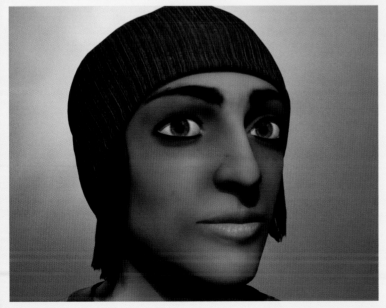

5

5. Beauty pass

Setting up a subsurface scattering material was a challenge, as it was the first time I had attempted it. The color and the diffuse textures were for this material. As I was using mental ray (the ray tracing package that ships with Maya), I used the mental ray Fast Skin Shader for subsurface scattering. Unfortunately, this shader does not seem to handle specular highlights very nicely, so I decided to render the image in separate layers. I rendered the beauty pass without specular highlights on the skin or hat, which I achieved by simply turning off the Emit Specular setting on all my lights. I usually render out an image in many more passes, dividing my beauty pass into a shadow pass, a diffuse pass (just flat color), an ambient occlusion pass, and a reflection pass. However, since I was happy with the beauty pass as it was, I decided not to separate it.

97

6. Specular pass

For the specular pass, I attached a black, shiny shader with no reflectivity to all the geometry. Then, remembering to turn Emit Specular back on for all my lights, I rendered out this image.

7. Clothing and face edge light passes

Rendering it like this gave me much more control over the strength of the highlight, and gave me the option to also include an edge light pass. The edge light pass is quite simply a cheat to get the look of a rim light without the extra render time and effort. Instead of using an extra light, I used a ramp shade that becomes white when it faces away from, but transparent when it faces toward the camera. The bump and specular textures were used in the specular and edge light passes. I divided the edge light pass further into clothing and face so that I could control their strengths separately at the time of compositing.

6

7A

7B

8. Composite

After rendering out all the passes, all that was left to do was to composite them in Adobe Photoshop and make subtle changes so that everything fitted nicely. For instance, the edge light pass left a strange white highlight on the inside of the nose, which I simply erased. I set the blending mode for the specular and edge light passes to Screen and made sure the beauty pass was at the bottom of the layers, then adjusted layer opacities until I was happy with the result.

All Images © 2008
JD van der Merwe

8

Artist profile: Julio del Rio

Country of origin: Spain (now living in UK)
Primary areas: Shorts (festivals and web),
 features, TV, commercials, video games
Primary techniques: 3D, 2D, interactives
URL: juliodelrio.com

Born in Pamplona, Spain, Julio del Rio
Hernandez trained in the studio of painter/
sculptor Antonia Eslava, before spending five
years at the Pamplona School of Arts. He finally
graduated in Fine Arts from the University of
Pais Vasco in Bilbao. Equally important for him
were the years in his father's stained-glass
workshop, where he developed an under-
standing of light and color.

Although his studies focused on graphic design,
del Rio had an early fascination with animation.
He taught himself the form's basic concepts and
techniques by reading books, and by creating
a 2D short film, *The Incredible Invasion of the
Green Plants* (1997), as well as a 3D short,
Visions of Eunate (1995). These shorts were
screened at various festivals and led to his
employment as layout artist, in-betweener,
and animator at Merlin Animation.

del Rio also worked as a 3D artist for
video-games developer Ubisoft in Barcelona,
and as animation supervisor for a TV series and
a feature-length movie in Luxembourg. He then
moved to Paris, where he worked as a freelance
animator for numerous clients in advertising,
including M&Ms and 7UP.

1–3. Stills from *Brothers*.

1

2

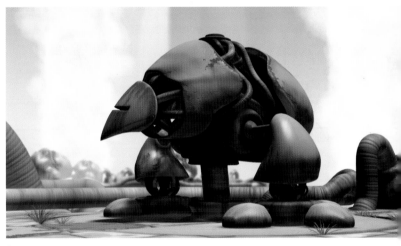

3

He later relocated to London, where he worked for Passion Pictures and The Mill. His projects there include music videos for the virtual band Gorillaz and commercials for The Carphone Warehouse, Comfort, and Duracell. He also worked as lead animator with The Moving Picture Company, working on *Prince Caspian*, the second *Chronicles of Narnia* movie (2008).

The birth of *Brothers*

Parallel to his professional career as an animator, del Rio single-handedly created the five-minute film *Brothers* (2004; juliodelrio.com/brothers.htm), an independently produced and financed project that took five years to complete. It was selected for several international animation festivals, including Cinanima, ArtFutura,

and Animadrid. "*Brothers* is my most ambitious, technically and artistically complex work to date, and also the one in which I have invested the most time and resources."

Brothers is the story of the mutiny of a slave robot who rebels against his imprisonment in a world in which he was meant to work until he dies. Beginning in 1998, the project underwent multiple revisions as production evolved, but for del Rio, it was "essential to maintain the idea and original structure of the story—the rebellion of a slave against his condition."

Since the robots are meant to be anonymous workers, del Rio designed them as faceless and voiceless. His challenge was to create a character that was only capable of expressing itself with its body.

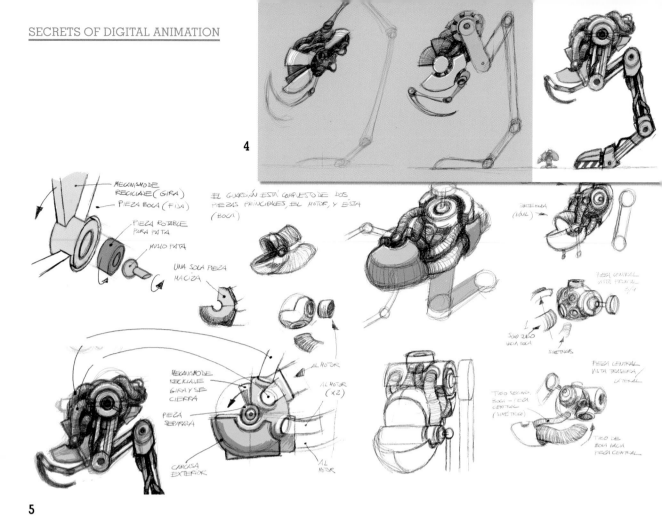

4

5

Design and production

del Rio's principal tools for *Brothers* were low-cost PCs running Autodesk 3ds Max, Adobe Photoshop, Adobe After Effects (for compositing and color correction), and Adobe Premiere. He created first drafts of the world of *Brothers* on paper, including the storyboard, which he then digitized and edited using Premiere.

"When I had an animatic of the entire short, and model sheets of the robots and the environment, production got under way: modeling and texturing first, followed by setup, animation, lighting and rendering, and finally compositing and final edit. I created every single step of the short myself, in my spare time and on weekends, while working as an animator at the same time."

del Rio designed the vast, open environment for the film, which is covered with huge domes inspired by those of Gothic cathedrals, as small "puzzle pieces" that could be duplicated and pasted after being rotated and mirrored. For the robot workers he started with a basic model that he varied using different texture maps. He hand-painted all the textures, which turned out to be one of the most time-consuming steps.

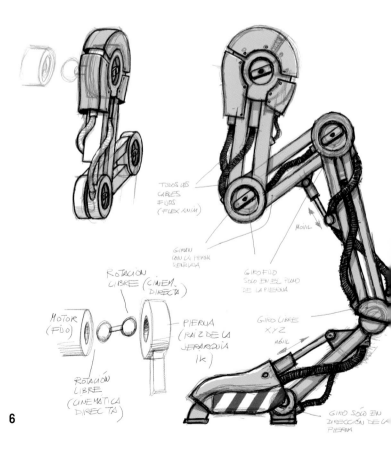

6

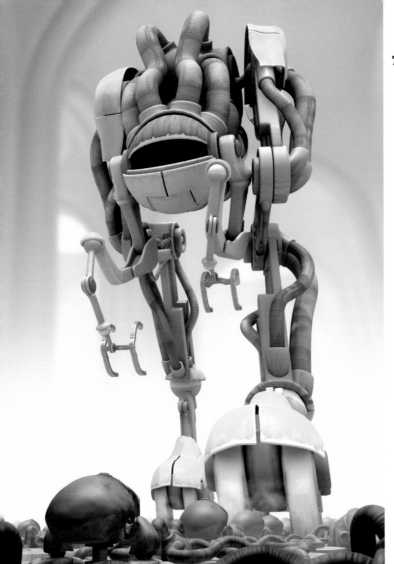

7

4 and 5. Digital drawings featuring details of parts of the El Guardian character from *Brothers*, a robot that destroys any dead and useless worker robots.

6. Digital drawing of the leg of the El Guardian character, used as a guide for the 3D model.

7. Full frame of the El Guardian character.

8. Wide shot of the *Brothers* world.

All Images © 2008 Julio del Rio Hernandez

8

Background elements were often reused from key scenes, to save time and effort. For rendering the final short, he connected several domestic PCs into a miniature network. All the elements in each scene were rendered as separated layers.

The soundtrack was created largely by recording natural sounds via a microphone, and then editing and mixing these using Sony Sound Forge. The film has no dialogue, but a professional musician, Chris Badge of Luxembourg, composed the gripping and atmospheric musical score.

"One reason for spending so much time on animation, both professionally and as a hobby, is the pure joy of breathing life into all kinds of objects and creatures," del Rio says. "I enjoy the spirit of investigation and experimentation (and occasionally suffering!) brought on by the challenge of trying to find the right way of animating an object or life-form. When it comes to producing a short film, animation is the ideal medium for an artist who wishes to work without boundaries. On a practical level, animation makes it possible for a single person to realize their vision using only a computer and software, or pen and paper."

Artist profile: Virgilio Vasconcelos

Country of origin: Brazil
Primary area: Shorts
Primary technique: 3D
URL: virgiliovasconcelos.com

Animator and director Virgilio Vasconcelos lives in Goiânia, a city located in the central region of Brazil, where he earned degrees in advertising and graphic design. Animation was an early passion, and he spent his childhood watching Looney Tunes cartoons and making flipbook animations using the pages of his schoolbooks.

Vasconcelos' graduation project in graphic design gave him the opportunity to pay homage to the work of director Chuck Jones, and also to

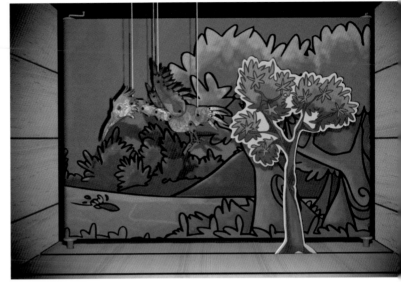

1

2

1–4. Stills from *Matinta Perera*, *Nhapopé*, and *Uirapuru* from the artist's series of shorts based on old Brazilian legends.

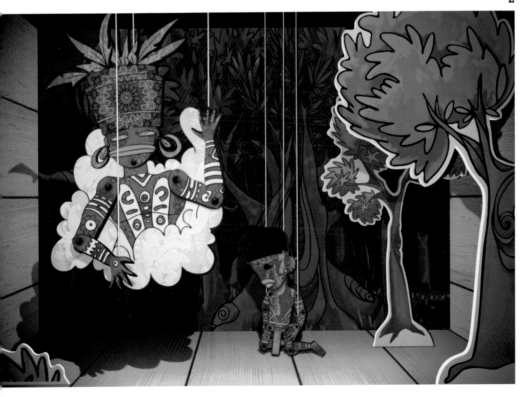

study the craft of animation. Along with Jovan de Melo, he recreated, in digital 3D, the 1955 classic *One Froggy Evening*. The pair focused only on the first scene of that cartoon, studying it frame by frame to understand the principles and techniques used.

"It was actually the first animation ever made at our school, which doesn't offer animation classes at all," says Vasconcelos. "There are no animation schools where I live, so we had to learn by reading animation books, carefully watching lots of different animations, and studying the originals frame by frame. Fortunately, it seems we achieved a good result, and it was well received around the Internet."

Tales from the Amazon

After graduation, Vasconcelos began to produce animated shorts, some by commission and others for personal study. Among the pieces was a series of five shorts commissioned by a local music duo, based on old Brazilian legends from the Amazon Forest. The shorts were made to be played on a big screen before the songs in the show were performed, and were all included on

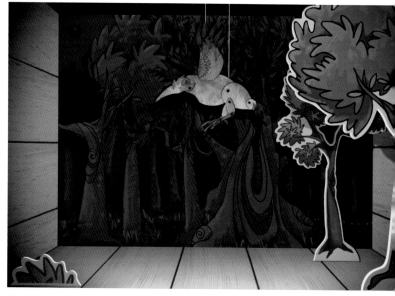

3

4

the duo's DVD. The series was nominated for the Best Designed Short Film category at the 2007 Suzanne Awards, given by the Blender Foundation in the Netherlands.

Vasconcelos made these shorts along with Jovan de Melo, who took care of the paintings, and Suryara Bernardi, who was responsible for character designs and drawings. The small team had a very tight deadline—a little more than a month to complete everything from script and storyboard to the final touches.

"Since we didn't have much time, the main idea was to make more stylized shorts," Vasconcelos says. "Each one had to have a visual connection to the others, so we came up with the idea of a puppet theater. That theater was basically a box lit by candlelight to give a warmer feel."

Once the drawings and paintings were done, Vasconcelos modeled the box and props, modeled and rigged the characters, set up the lights, and animated in synchronization with the audio provided by the musicians.

Olympic trials

For his newest independent short, *Clean Jerk*, which is now in production, Vasconcelos takes his inspiration from the cartoons of the 1940s and 1950s, especially Disney's *Goofy* and MGM's *Tom and Jerry*. His main challenge, he says, is to achieve visuals that are different from what one expects to see in a 3D short.

"Often, 3D animations try to achieve some sort of 'realism' in the visuals by simulating lights and textures from the real world," he says. "The purpose of my short is to get a painterly look and feel, with absolutely nothing real except the audio." The audio was edited from actual coverage from the clean and jerk weightlifting finals of the Athens 2004 Summer Olympics, broadcast by the ABC (American Broadcasting Company) network.

Vasconcelos created the concept, directed the short, and handled all storyboarding, backgrounds, design, and animation, with rigging support from Bassam Kurdali and Jason Pierce. His main production tools are free and open-source software such as Blender, The Gimp, Inkscape, and Linux. "I chose these tools both for their good quality and because they are more accessible to people in Brazil, who normally don't have enough money to purchase a few thousand dollars of software."

5

6

Of his country's place in the animation world he says, "Digital animation in Brazil has grown very quickly over the past few years. Each day more artists are getting access to the tools and learning resources needed to produce high-quality animations. We have some small animation festivals in the country and a big one called Anima Mundi that is held every year in Rio de Janeiro and São Paulo. This festival celebrated its 16th year in 2008, and the number of Brazilian productions is growing each year."

Advice to young artists

"Many animators nowadays are focused only on software applications, and on one particular style, and they forget that basically all animation principles can be applied to any style," says Vasconcelos. "Animation is a very wide art form that requires you to know about many things, like moviemaking, music, painting, acting, and photography, to name a few. Learning an application, for example, is like learning how to hold a pencil. It is obviously required for you to know how to use your tool, but only after you know what to do with it. Having a good background in the arts in general is also highly recommended.

"Also, with a good background in the arts you will be less attached to a particular style. We, as animators, have to be able to evolve along with this art form. So, try not to be prejudiced against any form of animation, be it 1950s cartoons, web-based Flash animations, **anime**, or 3D."

7

5–8. Stills from *Clean Jerk*.

All Images © 2008 Virgilio Vasconcelos

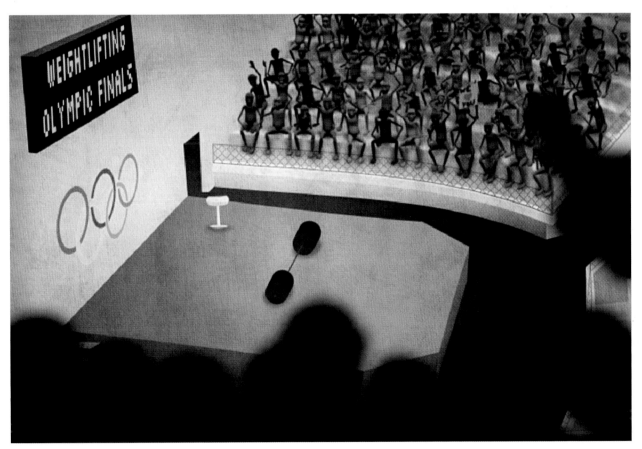

8

4 Interactive Animation

Game animation and machinima

To play or not to play

The intricacies of video-game animation are beyond the scope of this book; however, it is fair to say that "cinematic" animation (in which the main character's actions are meant to be *viewed*) and "interactive" animation (in which the player *controls* many of the main character's actions) are both part of the same creative spectrum. Animators often cross from one field to the other, and fundamental animation skills overlap the two forms.

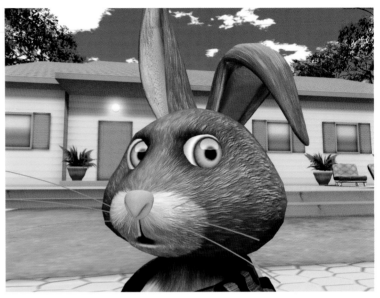

1

2

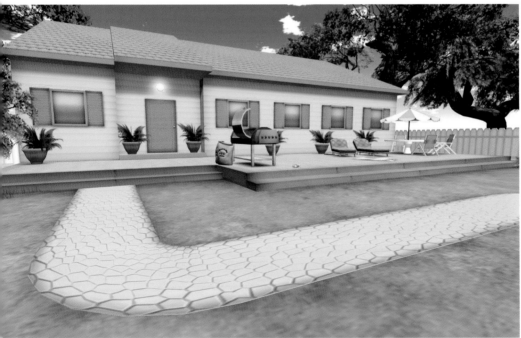

1–5. Stills from *Tiny Nation*, an original piece of machinima created by ILL Clan Animation Studios (see pages 112–115), directed and produced by Kerria Seabrooke.

All images © 2008 ILL Clan Animation Studios

Here are a few of the key areas that distinguish interactive animation from its cinematic cousin. In interactive animation:

- interactivity can extend to secondary characters and to elements of the game environment;
- limitations on available console power (the capability and speed of the game's rendering engine) can affect the level of visual detail and the quality of sound and movement; and
- artificial intelligence (AI) engines can control in-game character behavior and react in real time to changes brought about through the gameplay.

Cutscenes and FMV

According to Wikipedia, a **cutscene** is "a sequence in a video game over which the player has little or no control, often breaking up the gameplay and used to advance the plot, present character development, and provide background information, atmosphere, dialogue, and clues." Cutscenes—also called cinematics, in-game movies, and full motion video (FMV)—can either be animated or use live-action footage. FMV is especially popular in the role-playing genre and often renders at a higher quality of visual detail, sound, and movement than do the "playable" segments of the game.

Machinima

According to the Academy of Machinima Arts & Sciences (machinima.org), machinima (muh-sheen-eh-mah) is "filmmaking within a real-time, 3D virtual environment, often using 3D video-game technologies... [I]t is the convergence of filmmaking, animation, and game development. Machinima is real-world filmmaking techniques applied within an interactive virtual space where characters and events can be controlled by humans, scripts, or artificial intelligence.

"Machinima can be script-driven, whereas the cameras, characters, effects, etc., are scripted for playback in real time. While similar to animation, the scripting is driven by events rather than keyframes... Because machinima can be shot live or scripted in real time, it's much faster [and therefore cheaper] to produce than traditional CGI animation." [See pages 112–115 and 166–169 for more information.]

3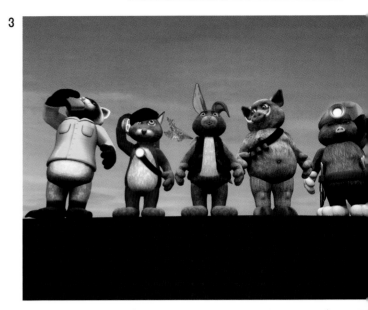

4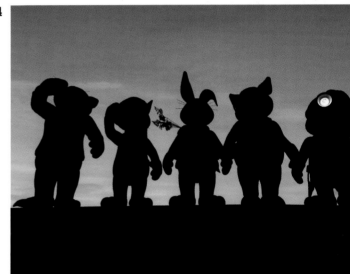

5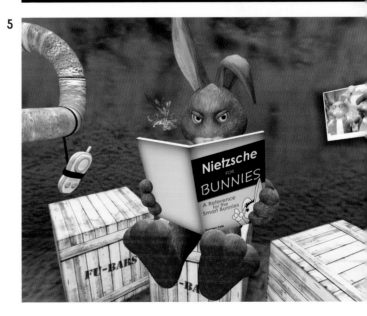

Skill profile: Machinima of ILL Clan Animation Studios

Country of origin: US
Primary areas: Shorts, spots, television
 series, festivals, live performances
Primary technique: Machinima
URL: illclan.com

The multiple-award-winning ILL Clan Inc. has been creating machinima since 1998 for world-class clients such as CBS, IBM, MTV, NBC, Spike TV, Microsoft, and Warner Bros. Named Machinima Masters by *Wired* magazine in 2005, the team recently adopted the new ILL Clan Animation Studios moniker.

2
1

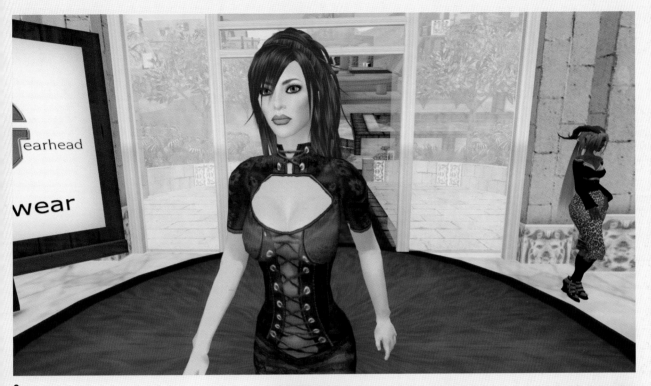

3

4

1–4. Stills from machinima sequences for two episodes from *CSI: NY*.

The ILL Clan is a machinima production team based in Brooklyn, New York. One of the earliest Machinima Clans (originally a Quake gaming clan), they created their first short, *Apartment Huntin'*, in 1997. Since then the clan has produced a number of machinima shorts, series, and live performances at film festivals, often interacting with the audience. Their work frequently makes heavy use of improvised dialogue. The team has been featured in numerous articles in various media.

The current members of the ILL Clan were a part of the virtual world's start-up services company the Electric Sheep Company in 2007 and 2008, serving as its machinima division, recording mostly in the virtual world of the popular *Second Life* game. The team produced a 2007 pre-Super Bowl spot for CBS using machinima for the show *Two and a Half Men*. They also produced a machinima segment for CBS's 2007 upfronts at Carnegie Hall that introduced their President of Sales to the audience.

"Machinima is 3D computer animation shot in real time in a virtual environment," says Frank Dellario, Director of Machinima Production. "There's no rendering, **avatars** are puppeteered, and animations are either triggered or procedural. The main reason we've chosen to work with machinima is that we can produce 3D animation about three times faster than we could with traditional CGI animation, and therefore at about a fifth of the cost.

113

5

"It's the adage of 'Let the tool do the work for you.' For example, the **game engines** have physics engines built in, so if a character has to knock a book off a table, we don't have to animate it—the game engine does. And it may drop the book differently each time, so it's like live-action filmmaking in that you can be surprised and frustrated at what you get."

Prime-time machinima

Starting in 2007, the ILL Clan produced roughly 25 minutes of machinima footage in high definition for two episodes of CBS television's *CSI: NY* and Anthony E. Zuiker, the creator of the *CSI* franchise [episodes 405 (aired October 2007) and 415 (aired April 2008)]. Machinima for both episodes was shot using the *Second Life* virtual world engine. In episode 405, the show's actors follow a killer into *Second Life*. This was the first time machinima animation was broadcast on a prime-time television network.

"Once the scripts were approved, they were sent to us where they were broken down," says Dellario. "Virtual sets were built, and custom avatars were created, sent to CBS for approval, and outfitted with custom animations and expressions. The Dingbat character in episode 405 was created in postproduction

6

Dellario on legal issues

Because there are many copyright and legal issues surrounding machinima, we at the ILL Clan have focused on creating all our own in-game assets or purchasing them from vendors. [It is important to note that copyright laws vary from country to country. See pages 166–169 for print and web machinima resources.]

Technically, if you create machinima using a computer game, you are using two separate pieces of material: the engine behind the assets, and the assets themselves, both of which are copyrighted. Many game companies support machinima because it helps to market their games and therefore increases their games' shelf lives.

But once you make money using an engine or its assets, then the game companies (and their lawyers) take notice. That's why we've mostly used engines with a user license (e.g., *Second Life* or GarageGames Torque Engine), or engines that have been released with a free public software license (e.g., *Quake* 1, 2, and 3), unless we've been hired by the game companies or their ad agencies to create a spot using their game engine (e.g., *Hellgate London* or *Half-Life 2*).

Although there are legal issues involved with commercial machinima, this shouldn't dissuade amateurs from experimenting with the tools and techniques. Though machinima as a medium is a little more than 10 years old, it's still very new. But we do believe that it will become widely used as a 3D animation production tool. It won't replace CGI, but it will augment what is possible, just as Adobe Flash has augmented 2D animation.

7

with an alpha channel dropped in over the footage when the character was supposed to speak. To give some guidance to the editors, a scratch audio track was added. To work with the studio, a custom-scripted 'slate' had to be created to mark all the shots to match up with the script. This saved an incredible amount of time as, without the script, all the slating needed to be added shot by shot in postproduction."

For episode 405 there were two waves of machinima. First, there was "on-set" machinima: scenes for which the actors were actually in front of a large screen. The second batch was cut into the episode in the editing room. Software to model and import avatars ranged from Autodesk Maya on the high end to Poser to create animations and pose-balls. For the footage, the applications VirtualDub, Final Cut Pro, Adobe After Effects, QuickTime Pro, and Movavi were used to create files of the right size.

For episode 415, much of the same process applied, except the team also used CrazyTalk to animate the faces and make the characters appear to speak. "What is interesting is that this occurred prior to the advent of lip synch in the release client, so it made for a nice 'prediction' of the direction *Second Life* was heading in," says Dellario.

5–7. Stills from machinima sequences for two episodes from *CSI: NY*.

All images © 2008 ILL Clan Animation Studios

Skill profile: Pixel animation of Adam Tierney

Country of origin: USA
Primary area: Interactive handheld games
Primary technique: Pixel
URL: adamtierney.com

1

For Adam Tierney, pixel animation is more than his day job—it is a tool for personal expression. This southern Californian native now works at Los Angeles–based handheld game developer WayForward Technologies. Though he was an English major at the University of California Riverside, and originally planned to be a teacher, game development captured his attention around 2000 and, shortly afterward, he started freelancing as a pixel animator. His animation influences have ranged from Disney to anime to stop-motion work from the likes of the Brothers Quay and Terry Gilliam. He also lists comics artists Chris Bachalo and Stan Sakai as artistic heroes.

His current projects include directing an action game on the Nintendo DS and a horror game on the Wii. He also contributes animation to most of WayForward's projects, such as *Contra 4* for the Nintendo DS and *Sigma Star Saga* for the Game Boy Advance.

"For all pixel artwork and animation," Tierney says, "Cosmigo's Pro Motion has become the industry-standard tool. It's fantastic for pixeling, animating, and palletting, and most pixel art in our games is created there." Adobe Photoshop is the go-to software for nonpixel 2D artwork, such as menus and character portraits for cutscenes. For most aspects of 3D games, including modeling, animating, and level designing, WayForward artists use Autodesk 3ds Max. "Beyond that," he says, "most of our tools are proprietary ones developed by in-house programmers."

2

At WayFoward it's the job of the art director to maintain a consistent art and animation style across a game. This involves ensuring that work from different animators has a similar style from character to character, and that it also matches the overall intended style. In this role, Tierney handles all art and animation assignments for a project, and as the work comes in from the pixel artists and animators, he'll make adjustments or suggestions for revision.

"It's pretty hands-on," he says, "although I typically do less work from scratch myself now, since my time is better spent helping everyone else out. Most of the artwork I've done from scratch is for menus and interfaces in temp format, so the artist who will do the final art can just trace over the existing layouts. I also tend to do lots of minor animations, since it's sometimes quicker than assigning them to an artist."

3

4

1–6. Pixel characters from various independent projects by Adam Tierney.

5
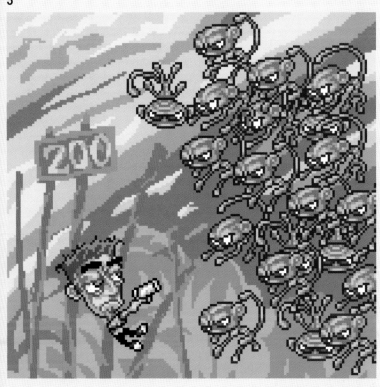

6

Animation's appeal

In terms of the effort required, Tierney believes game animation is one of the most satisfying roles in the games industry. "I can sit down for a day or two, whip up a half-dozen animations for a character, and it's ready to be coded and given life in a game," he says. "Animation is also very relaxing mentally because each quick decision leads to several minutes of carrying that decision out: it's nice to tune your brain out and listen to music as you work on each frame."

He finds 3D animation much easier to do, in general, because it's not necessary to stay "on model" or to re-render minute details in each frame. "It often loses the artist's touch that pixel and 2D animation showcase, but it's a much speedier process, and also easier to tweak," says Tierney.

As an example of the type of decision making that goes on at WayForward: on some of the pixel-based, comic book–inspired games Tierney has worked on (*X-Men*, *Justice League*, etc.), his team decided to go with a snappier, punchier animation style, with characters snapping to their key poses and holding them, rather than featuring fluid and even movement. "This was because comic books are made entirely of these frozen action poses, and we wanted

7

8

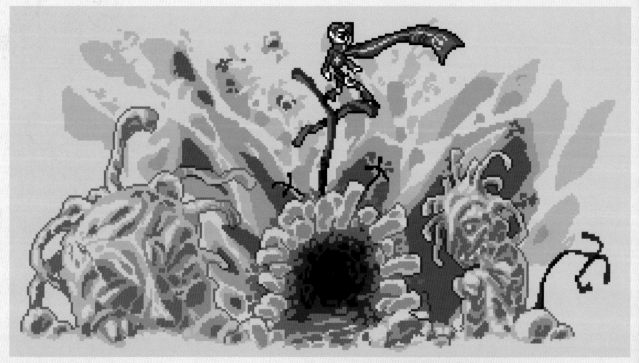

to carry that over to the games. When Wolverine slashes with his claws, we wanted that slashing pose to stand out to the player, not just the fact that he is slashing."

In an opposite scenario, WayForward finished the Nintendo DS game *Shrek: Ogres and Dronkeys*, a baby simulation game, in early 2008. "Even though ogres and dronkeys aren't the same as real babies," Tierney says, "we wanted to strive for realism in their movements, so these animations were a lot more subtle and referenced live-action footage of babies. In an action game, a baby might hop on a block in a second with little difficulty, but in this game the babies would take several seconds to lumber up the block, using hands, thighs, and stomach."

What Tierney finds most appealing about game animation is the work to result ratio. "In a motion picture, the animators are animating everything the characters do with little to no reuse of those animations. In game animation, everything is reused, and depending on the camera perspective, a walk cycle might only be animated once, but that animation might be playing for half the time the player is enjoying that game."

7–10. Pixel characters from various independent projects by Adam Tierney.

All images © 2008 Adam Tierney

9

10

In terms of the games industry at large, Tierney compares working in handheld development with making independent films. "There's a lot of crossover between roles, and the staff is generally much smaller than on a console game. Whereas a multimillion-dollar console game might have one animator dedicated to animating foliage, a single handheld animator might do all effects animation and half the character animation in a game. You also see more multitasking on the part of the project lead, where instead of just directing, that person might also handle game design, level design, art direction, and some animation or pixeling themselves."

Tierney sees handheld games as a return to the old-school pixel-art styles that have otherwise been abandoned in the games industry. With a shorter development cycle than console games—usually six to nine months from start to finish—teams can work on at least two different projects per year, which can be creatively rejuvenating.

Artist profile: Michael J. Wallin

Country of origin: USA
Primary areas: Interactive, 2D, 3D
Primary technique: Character animation,
 wide range of media
URL: michaeljwallin.com

Born in Tachikawa, a western suburb of Tokyo, Japan, games animator Michael J. Wallin first lived in a giant aircraft hangar converted into homes for American military families. Later, he moved with his family to the Philippines and to various locations in the United States, eventually settling in New Mexico, where he spent his grade-school years.

"I had an ideal childhood in some ways," he says. "My parents were always traveling and doing activities with us. I have traveled coast to coast across the United States at least 20 times. We also traveled the world, usually visiting relatives in Europe. Travel was a great perk for a military brat, seeing historical sites and museums all over the world and dodging occasional incidents during the Cold War." Because of his upbringing, Wallin discovered fine art early in life and went on to take classes in visual arts, engineering, industrial design, drafting, and printing. At one point, for extra money, he painted Southwestern-style acrylic paintings on rustic-looking camp wear, coffee pots, mugs, and plates that were sold to tourists in Dallas, Texas.

Imaginative animation has always fascinated Wallin, along with comic books, magazines about heavy-metal music, and reading. His first artistic influences, however, were the traditional masters. He also liked science, science fiction, and fantasy, which led him to computers, video games, and programming. "I liked the process of creatively breaking down problems into their basic components," he says, "but computers then couldn't do what I wanted artistically, so I stayed with more traditional techniques."

1–4. Samples of digital art from games, including *Shadow Warrior* (3D Realms/ GT Interactive; 1996).

5. Life drawings in ink.

6. Funbot loose body sketch in ink.

7. Character designs for animation and expression in ink.

8. Beholder dance animation, sketch of animation motion.

All Images © 2008 Michael J. Wallin

He won a prestigious art scholarship and chose to study commercial creative design and illustration at the Colorado Institute of Art (now the Art Institute of Colorado). After graduating he moved to New York City, which proved risky because it happened to be right after the Black Monday stock market crash of 1987. "All the companies I was talking to were devastated," he says. "I was offered a job in my home town, but I craved the excitement of the biggest city I could find, so I packed up my portfolio and art supplies and headed out to my uncertain future." Fortunately, he soon found a graphic design job.

Forging a career

Wallin's first few years in New York centered on traditional media, graphic design, illustration, art direction, storyboarding, product development, marketing, and advertising, and he designed everything from toys and silverware to edgy furniture and children's products. His computer gaming career started in 1988, at a graphic design firm in Manhattan where he developed children's story images for educational books and marketing materials. He designed the characters for a game called *Remote Control*, a spin-off of the then popular MTV game show, and also worked in a limited way on some Sesame Street properties.

After more than eight years as senior art director and interactive designer focused on interactive entertainment and edutainment, Wallin decided to become a full-time animator for the gaming industry, also working on creative development, character design, interactive animation systems development, character tech art, and 2D/3D art. Previously he had helped to develop advanced applications, incorporating blue-screen technology and other virtual environments (some fully immersive), for companies and governments, covering all types of education, training, sales, tourism, marketing, information, and entertainment.

One of his first action-game prototypes was created in 1996: an antiterrorist project for the US Special Forces. He then worked on the first-person shooter game *Shadow Warrior* (1997), developed by 3D Realms and released by GT Interactive. Over a period of 12 years from 1996 he worked on more than a dozen games for the PC, Sony PlayStation 1 and 2, Microsoft Xbox, Nintendo Wii, and other platforms. He has helped to create numerous animation systems covering many needs from combat to conversation, and everything in between. His game development client list includes Electronic Arts (EA), THQ, Foundation 9 Entertainment, Turbine, 3DO, 3D Realms, and N-Fusion.

"Creative problem-solving and thinking outside the box are my greatest strengths," Wallin says, "and I have applied those skills in many industries. I like to keep busy and love the process of creating things. I draw most days, coming up with concepts for stories and inventions. I still take art classes and life drawing, as well as anything new that piques my interest. There's nothing more enjoyable for me than bringing the illusion of life to things you can actually interact with. But primarily I choose to work in game development because I am drawn to doing my own nonlinear interactive storytelling, and I like the ability to create environments and situations that are immersive, flexible, and reactive."

7

8

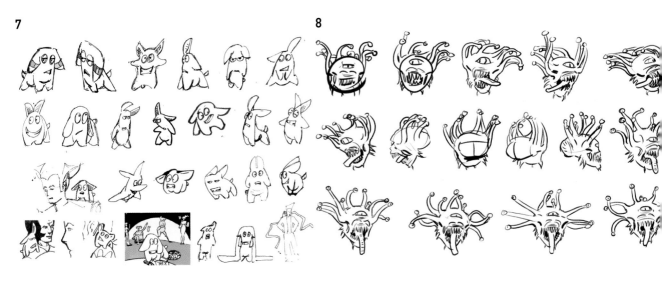

Animating for MMORPGs

In the mid-2000s, Michael J. Wallin was a senior animator for the massively multiplayer online role-playing game (MMORPG) *Dungeons & Dragons Online: Stormreach (DDO)* for Turbine Entertainment (2006). He was the only animator on *DDO* for the first year and a half, and functioned as animation director and 3D character animator with a huge workload. He did the majority of the animations, and he directed or set up the production procedures for the rest. He also developed the look and feel of the animation and trained other animators on staff, along with a team of inexperienced animators in an outsourcing company in China that was part of an art school—none of them able to do the job until he got them up to at least an 80% quality level.

"Turbine was an unknown company to me at the time," he says. "They wanted someone with heavy-duty production experience creating animation movement and combat systems who could animate anything. My prior experience enables me to know how to work within limitations and ask the right questions. They wanted me to help a mostly young production team with a few massively multiplayer online (MMO) games under their belt. The games they had done previously were very fun MMOs with very basic combat and animation systems of 15 to 25 animations per character, including player characters with little to no dynamic blending.

"I was told by the producer that I was responsible for the animation look. I wanted to make the system more dynamic looking, even though there was fear of the unknown and they intended to keep the old system, unless I could convince the right people. So, the next step for me was to convince the programmer and scripter of the benefits of doing the extra work needed to develop a more dynamic system. They embraced the idea and said if I did the extra work they would try to place it. The animation deadline crunches mostly had to do with influences outside animation such as changing character models' designs, managing and training inexperienced outside animators, and handling other bottlenecks."

Wallin has often been the only animator on a game and knows how to create time-saving approaches, and he proved to be a good choice for *DDO*. He worked more than 90 hours a week for well over two years. "I would have had crunch time based on unexpected needs on a project anyway, but that would normally last weeks to months rather than years. For *DDO*, I sometimes arrived at work at 4am in the dark and cold Boston winter and worked until late in the night and many weekends."

In the following pages, Wallin describes the type of work he did on *DDO* in detail, revealing the multifaceted and collaborative nature of game development.

Primary tools for animation

* Autodesk Maya and 3ds Max
* Adobe Photoshop
* Microsoft Visio for flowcharts
* Proprietary tools used for animation
* Ink and whiteboard
* Various version-control and scheduling packages

1

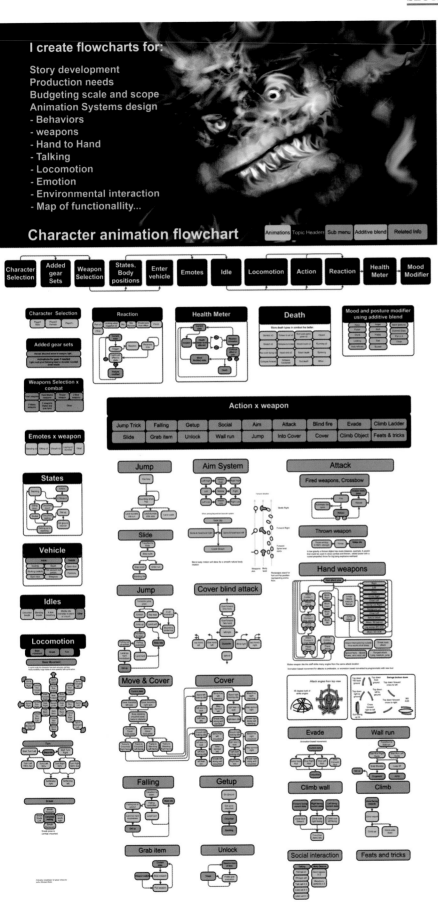

1. Flowchart for base character animation. Text indicates the steps in the workflow.

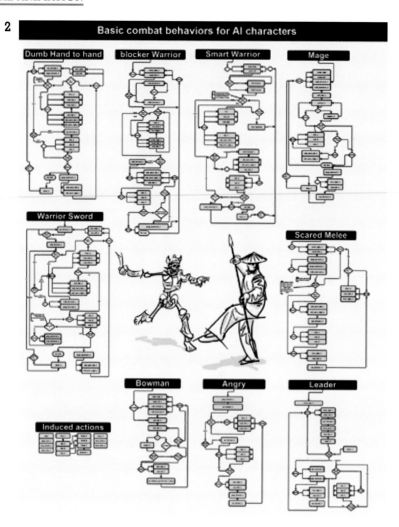

2 Basic combat behaviors for AI characters

2. Flowcharts provided for combat behaviors and artificially intelligent (AI) characters using existing animations. Text indicates the steps in the workflow.

3. Thumbnail sketches for development of staff animation.

The collaborative process

Animation preproduction

In this phase, we work out problems and make plans for future needs by developing procedures that work best with the people in place. This includes game evaluation, scale and scope, technology evaluation, style direction, functionality flowcharts, animation lists, time estimates, schedules and tracking sheets, and production procedures. It occurs whenever a new type of asset is needed.

Game evaluation

This involves identifying the type of game we are doing, and the target market.

Scale and scope

How complex should the game be? Most often, this comes down to the schedule, the man-hours available, and the technology that needs to be developed. The first thing I always do is break down the basic needs for functionality, add my own expanded options for discussion, and proceed from there.

Technology evaluation

We identify what tools we need to create to do the job, or to save animation time or streamline things, and look at how we can improve the current technology by looking at previous in-house game systems.

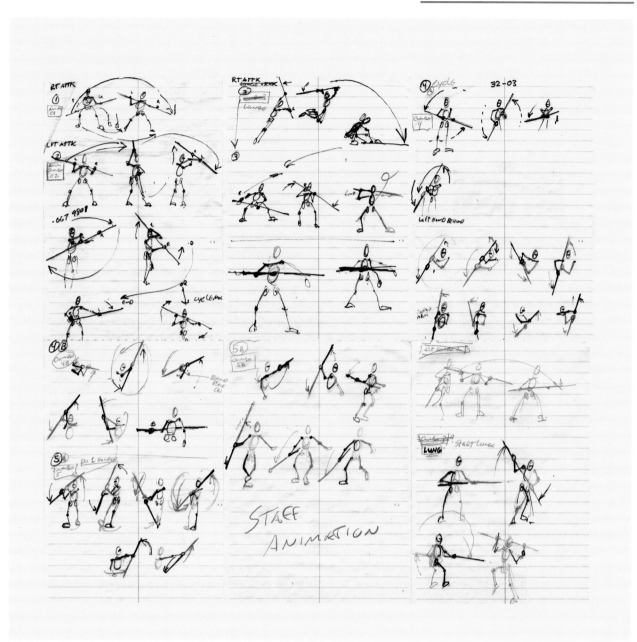

STAFF
ANIMATION

3

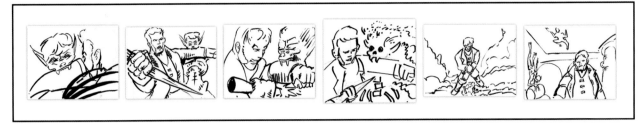

4

Style direction

We consider what we want for the game's overall look and feel: characters and environment as well as tech are considered. I need to work with all departments, directing and inspiring the animation's creative development and the necessary tech.

Functionality flowcharts

Before Turbine I had 14 years of experience in interactive design, so I create flowcharts (see images 1 and 2) to understand complex systems and communications. I break down how things can work and what is needed. Through the flowcharts I find holes that may be overlooked in the process, and I also devise dynamic ways of using animation sequences and technology.

Animation lists

When we evaluate function, we create a more finalized asset list with file-naming conventions. I work with everyone needed.

Time estimations

This is when we commit to a due date. We try to be as realistic as possible, then add a percentage based on unforeseen obstacles and potential needs. Companies rarely know how complex animation systems are, so the flowcharts help everyone understand time estimates.

Schedules and tracking sheets

Microsoft Excel, Project, or other types of documents for tracking progress and asset breakdown are kept current for integration into project schedules.

Production procedures

This involves identifying what meetings I need to be in, and what production steps are needed for acquiring references, naming needs, flowcharts, setup needs for characters and rigs, animation blending, animation systems, animation creation and assets, character development, etc.

Developing animation systems

I brainstorm ideas, flowchart things if needed, and create animation tests to explore approaches with tech. In discussions I can creatively target several approaches, working with programming experience or available technology. I can have over a dozen layers of blended animations working together, mixing parts like upper/lower body, head look, outside influences, expression, talking, aiming, flinching, and many other needs.

As the only new person on animation, I happened to have more combat experience on many platforms other than MMOs, so I was very open to possibilities for what an MMO could be. I pushed for a more advanced system when I found that it would fit our needs and I could

4. Storyboard sequences
for a vampire game, a game
with a gunfight sequence,
and other miscellaneous
storyboard images.

see no tech reason why not. I was able to
influence the game way beyond what the
company had thought was possible in an MMO.
It was less complex than I would usually have
for an action game because this was an MMO,
but it was still a far more complex system than
the company had previously done.

Animation creation and assets

This involves testing with programming to
find out what your limitations are for rig and
model in the game environment. I then come
up with a plan that makes sense for production
and find out if anyone needs something in
a particular order for a demo or for programming.
I gather reference when needed. I like to
make each animation a work of art, but also
have to be mindful of meeting deadlines.

To create quality animation quickly and
consistently, I try to make first-pass animations
of shippable quality so that they are easier to
debug. Also, with tight deadlines, sometimes
you only have one shot at something. I then
expect to make adjustments for tech, look,
and timing refinements, and adjust my approach
to fit the needs. On *DDO*, the animation had
a major influence on the game level size and
how the combat areas were designed for
frame-rate needs.

Character development

First I assess design and make suggestions
in order to avoid problems in movement.
As the model is developed, I figure out how
parts will work together. Often what looks good
on paper is totally nonfunctional and is more for
inspiration; it may need to be interpreted if you
want a character with natural movement. Next
I model, review, and guide the process to avoid
problems with the texture and how it will work
when rigged. I often adjust models for my own
needs myself, but not on this project. I then
calculate the number of polygons needed for
animation function, and determine how the
polygons fit together. After that I oversee rigging,
directing, and testing needs, and finally, manage
testing, which is ongoing.

Systems testing and development

Locomotion, combat, jumping, boxes exploding—
everything that animates in the game is part
of a system that requires assets, technology,
animation, and triggering. Character-animation
systems can be very complex and require lots
of testing and adjustments because they are
designed to be seen from all sides and mix
many different animations on the fly in a way
that makes them appear smooth and natural
to the character.

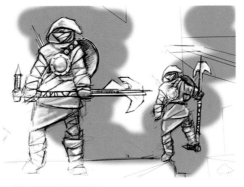

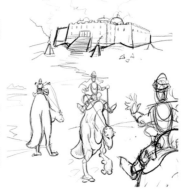

5

5. Character sketches.

6. Digital illustration and design.

All Images © 2008 Michael J. Wallin

Tools development

If I have repeated actions or specific needs, I may require new tools. Often the company will not know what you need as an animator because of all the differing levels of technical experience. Tools will get created if you make the case that it will save the company time and money and/or improve quality. If I need a tool, I talk to the programmer and see how possible that is and how much work it would take.

Game design

From the designers, I received information needed for *Dungeons & Dragons* feats, that is, special moves such as multishot arrow or timing, and various details related to the board game. I supplied flowcharts describing character behaviors in HTML using the existing animations, linking to movies so the designers would understand how the animations fit together.

Programming

I can't do anything without programming or tools. A programmer may or may not have experience with complex animation systems, so I can target the needs to fit their time or capabilities.

Tech art

If I have a tech artist, their focus is on efficiency and figuring out technical problems. On this project they spent their time in books, tutorials, and refining tech tools to solve problems that affected others. Having a tech artist gives me more time to direct the look and feel of animation, creating assets and developing tools with programming that enhances animation.

Art direction

The art director helped to develop the character and environment look. I worked with them to adjust the model for animation needs. When I was directing the outsource animators they attached my direction and sent it to the translators in China.

6

5

Mixed Media

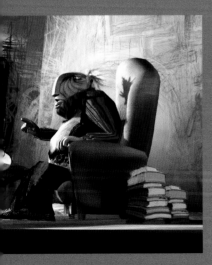

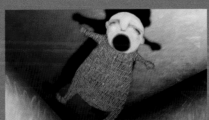

Skill profile: Stop-motion music videos of Adam Bizanski

Country of origin: Israel
Primary areas: Music videos,
 commercials, shorts
Primary techniques: Stop-motion,
 mixed media
URL: adambizanski.com

Born in 1983 in Haifa, Israel, and now living in Tel Aviv, director and animator Adam Bizanski has been drawing and sculpting for as long as he can remember. "My father is an architect, my mother a graphic designer and photographer, and my sister is a classical singer, so I guess my connection with art isn't coincidental," he says.

In recent years, Bizanski has collaborated with bands such as Zero 7, The Shins, Wolf Parade, Dntel, and Guster, establishing a varied repertoire of mixed-technique music videos. His critically acclaimed works, featured by MTV, *RES*, *Boards*, and *TimeOut*, have appeared in many festivals and exhibitions around the world. Recent projects include commercial spots for Sony Ericsson, *The Observer*, Huggies Little Swimmers, and ING Bank.

Stop-motion animation

This is the technique by which physical objects are moved by very small amounts between individually photographed frames, creating the illusion of movement when the series of frames is played as a continuous sequence. Also called frame-by-frame animation.

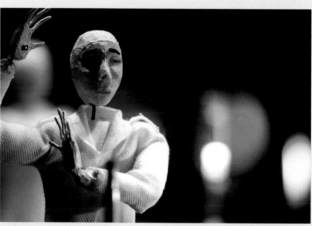

1

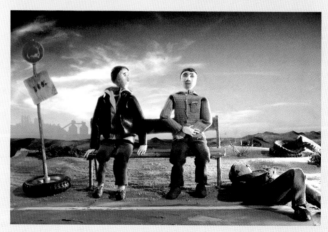

2

1–4. Stills from Bizanski's video for Wolf Parade's "Modern World."

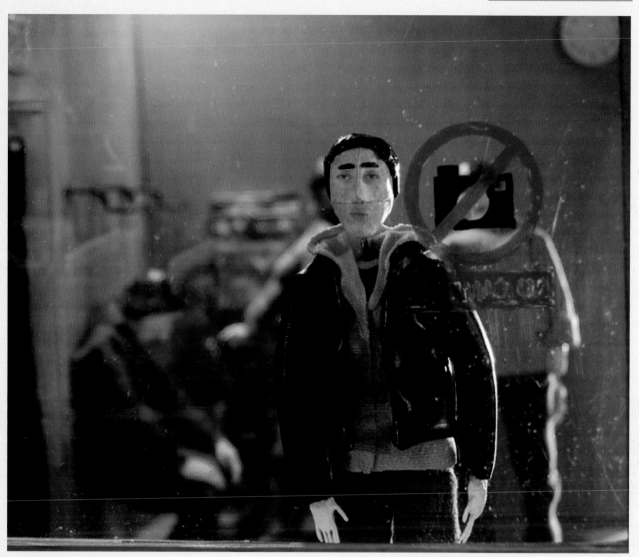

3

"I made my foray into stop-motion animation in high school, but never got any formal education," he says. "By the time I got discharged from the mandatory three-year stint in the Israeli military (Field Intelligence Corps), I was already making music videos independently and felt I was making good progress on my own, though I made a point to myself to try to push things further as I went along."

Surprisingly, most of Bizanski's sources of inspiration do not involve animation. "Music is probably my greatest influence, and that's part of the reason why I like working on music videos so much. I also find illustrated children's literature, Walter Trier and Tove Jansson especially, very inspirational."

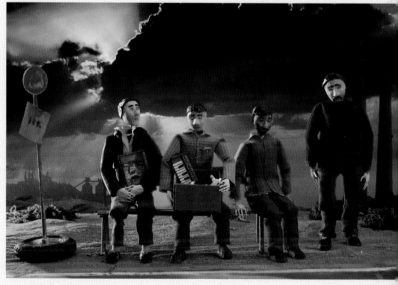

4

Wolf Parade's "Modern World"

After hearing Wolf Parade's first album, *Apologies to Queen Mary*, in 2005, Bizanski e-mailed Sub Pop Records (the band's label, with which he had previously worked on a video for The Shins) to ask for permission to make a video for the song "Modern World" (2006).

This was the first project in which Bizanski used a digital stills camera; he used a video camera for all his previous projects. "This was quite a leap in quality and source material flexibility for me," he says. "After shooting, I moved frames straight from the camera into Adobe After Effects, then edited and tweaked in Adobe Premiere."

Work on this video took Bizanski about five months, two of which were dedicated to building the sets and puppets, two to shooting and animating, and a final month to post-processing. It was quite a personal

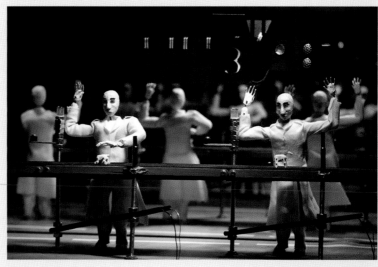

5

6

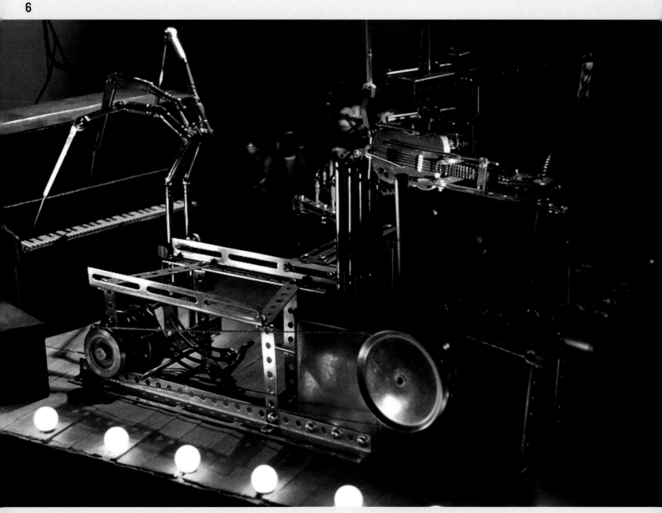

7

project for Bizanski, allowing him to take the time to work on all aspects by himself—from building sets and armatures, to animating and postproduction work.

"It is the sculptor's sensibility that most attracts me to this technique," he says. "The notion of creating a still character and making it come alive is magical to me. The curiosity of wanting to know how it will behave and act in the real world is what pushed me to make that very first attempt. Later, I discovered that stop-motion is one of the only techniques that allow you to directly convert hard work for production value. It's perfect for low budgets and small crews. The more you work on something, the better it looks. There are no bottlenecks as there are with live action.

"Working on music videos is probably as close as I will get to making music myself. It gives me a chance to take a song I love, and sing along in a legitimate way. Aside from allowing me to be a part of the process, I just see the music-video format as a beautiful, poetic film genre."

5 and 6. Stills from Bizanski's video for Wolf Parade's "Modern World."

7. Bizanski at work on the music video.

All Images © 2008 Adam Bizanski

Skill profile: Performance pieces of Miwa Matreyek

Country of origin: USA (raised in Japan)
Primary areas: Shorts (festivals and web), performance work
Primary techniques: 2D, performance works (animation and live action)
URLs: semihemisphere.com, cloudeyecontrol.com

Miwa Matreyek grew up in Japan and moved to Redwood City, California, in 1990. She received her MFA (Master of Fine Arts) for Experimental Animation from the California Institute of the Arts (CalArts) and now lives in Los Angeles, where she creates animated short films as well as performance works that integrate animation and live performance. She also freelances for a motion-graphics company.

Her animation shorts have been shown at LA Freewaves; San Francisco International Asian American Film Festival; Philadelphia Film Festival; and Platform International Animation Festival, the time-based art festival in Portland, Oregon. Some of her collaborative

1–3. Photographs from a live performance of *Dreaming of Lucid Living* at the Platform International Animation Festival. All photos are credited to Holly Andres.

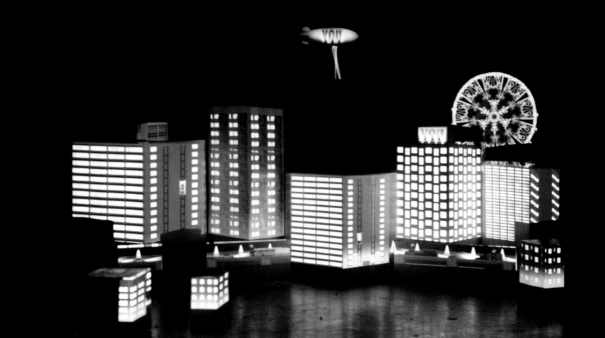

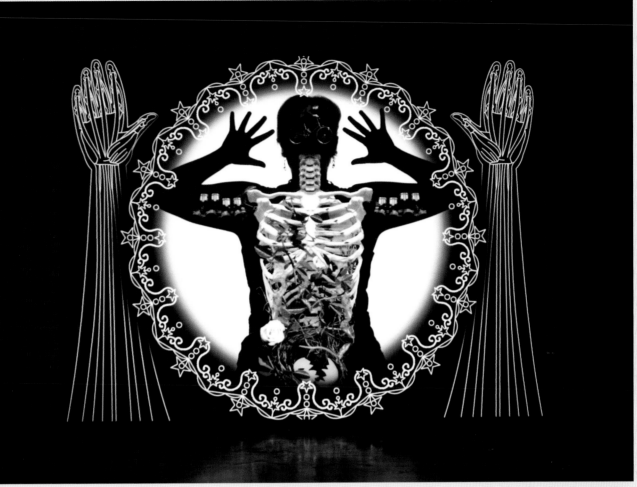

2

3

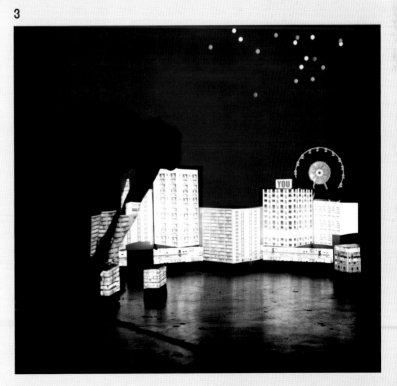

video–performance pieces were shown
at Edinburgh Festival Fringe in Scotland,
Platform International Animation Festival, and
the San Francisco International Film Festival.

Matreyek's interest in science informs
her videos and animations, which often deal
with biology, anatomy, and technology; in
understanding physical systems, processes,
and objects, and expressing a sense of awe
about the wonders of the worlds around us.

Music is another driving force. Her work
in animation began by combining her 2D still
work with music she recorded on a 4-track
machine to give it the dimensionality of time
and a narrative arc. Her animations are firmly
tied to the soundtrack; she makes animation
to the music, rather than editing to it in
postproduction. Dance and choreography
are often integral.

Lucid dreams

While at CalArts, Matreyek met fellow students Chi-wang Yang, a theater artist, and Anna Oxygen, a composer and performer. In 2005, the three formed an interdisciplinary, multimedia performance group called Cloud Eye Control. Their collaborations inspired Matreyek to create a solo performance piece for her thesis, *Dreaming of Lucid Living* (2006; semihemisphere.com/lucid_living.html). It won the Princess Grace Award for Film, as well as two awards at the Platform International Animation Festival: Student Grand Prix and Audience Choice Award for Best Installation.

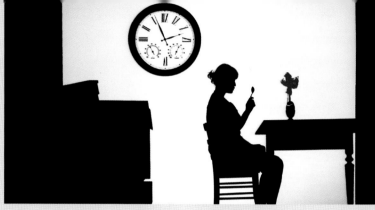

4

Matreyek plays with ideas of domesticity, female strength, fertility, the mysteries and mythologies inside and outside the body, body as architecture, voyeurism, the act of creation, and a sense of interconnectedness of the individual to the larger community of the city.

She uses mainly Adobe After Effects, along with Flash, Photoshop, and Final Cut Pro. She often incorporates drawn/vector animation from Flash, rotoscoped and manipulated video, and layers of images composited in After Effects to create an animated collage.

"My process is a collage in itself, through which I start to make sense out of a mass of snippets and ideas," she says. "I work mostly on my own, and often in secrecy, as I shoot video footage of myself, parts of my body, or a process, for example, frying an egg or a time-lapse of plants. I do a lot of research and web searching as I develop my pieces, which helps me broaden my subject in a more visual and metaphorical way as the scope for possibilities widens with each tangential Google image or Wikipedia article I discover."

She likens her experiments to the pioneering vaudeville shows of Winsor McCay and Gertie the Dinosaur—an expertly choreographed interaction between live performer and animated character. Almost a century later, performance artists like Matreyek make use of real-time interactive software such as Cycling '74's Max/MSP and Jitter (cycling74.com).

4–6. Photographs from a live performance of *Dreaming of Lucid Living* at the Platform International Animation Festival.

All images © 2008 Miwa Matreyek. All photos by Holly Andres

5

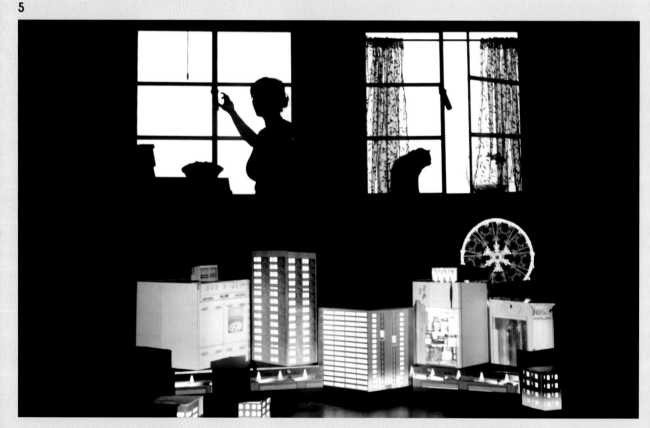

In one of her Cloud Eye Control pieces, *oceanflight* (semihemisphere.com/Ocean_flight.html), a very simple patch in Isadora is used to process live video for projection and layering with a premade video. "However, our approach to performance is influenced heavily by cinema and theater," she says. "With our pieces, we are telling a narrative, and the visuals are very rich. In contrast, most other new media, interactive performances, and installations tend to be simpler visually, as processing software often can't handle heavy video, and they generally focus on a single concept rather than a complete narrative."

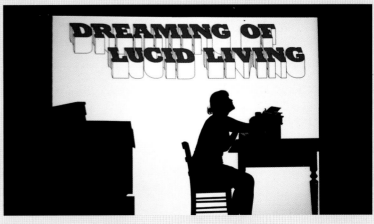

6

Matreyek on *Dreaming of Lucid Living*

On one level, the piece is a fantastical, magical, whimsical performance. It is a highly visual and cinematic event. On another level, it critically addresses the intersection of cinema, theater, performance, and art, confronting the language and conventions of these media by merging and diverging scale, time, body, physical and nonphysical space and events, cinematography, and staging.

My goal is to bring the fantastical world of animation into the real world. By making the projection intersect with a real body and real space, the animation takes on the gravity of physicality and consequence, while the real objects and space take on an element of the fantastical and magical. Painted cardboard boxes become a growing and living city. The mysteries of anatomy are revealed on a person's shadow as if by X-rays. Through the use of shadow, silhouette-style animation, and some sleight of hand, the line between what is real and what is not real becomes blurred, creating a simultaneous sense of suspension of disbelief and belief.

Although the performance is designed to be seen from the front, I am also interested in the audience being able to see some of what happens behind the scenes. For example, during the anatomy sequence in *Dreaming of Lucid Living*, the performer moves farther and farther away from the screen in order to get larger shadows of various parts of their body, creating a zoom-in effect on the screen. The audience viewing from certain vantage points can see how the performer creates images with their body, and each member gets a different experience of the piece. By allowing the audience to see what is happening on the screen cinematically, but also to see what is happening behind the screen theatrically, the viewer sees two parallel narratives: the magic of the illusion, and the unveiling of the tricks behind the magic.

Something I find very significant about my work being a live performance is the struggle of the human body to fit into the cinematic space. The live movements are choreographed to the video and music, so the body is able to hit the cues and complete the illusions of the projection. However, in some moments, the strain of the human body is visible: for example, as an anatomy image is projected onto the shadow of a performer's hand, there is a physical sense of struggle as the hand shakes while trying to keep it in place for the projection. Without the live performance aspect, this struggle loses much of its power.

Artist profile: David O'Reilly

Country of origin: Ireland (now living
 in Germany)
Primary areas: Shorts, features, music videos
Primary techniques: 2D and 3D
URL: davidoreilly.com

"I think there is a very real possibility of creating noncommercial cinema for the first time in history," says Irish animator David O'Reilly, who is now based in Berlin. "Andrei Tarkovsky spoke of how cinema was an unhappy art because it was affected by supply and demand, but that simply doesn't apply to digital animation; you can work on such a tiny scale, comparable to painting or composing. Fundamentally, you don't need to explain what you are doing at every stage of production, you can just follow your instincts, which is the same guiding principle practically every other art form enjoys."

Following his instincts has led O'Reilly, who is still in his early twenties, along a more or less self-directed path, and he has come to enjoy his maverick status. He professes no connection to the animation world at large, he rarely watches animated films, and most of his friends are from other fields. "At the same time," he says, "there is a kind of strong brotherhood between animators; we all know it's a constant struggle to keep going in a medium that is underappreciated and plagued by genre and cliche. We also all share this secret love for movement; it's the one thing that separates us from every other form of expression."

After leaving animation school in Dublin to work with Shynola on sequences for the feature film *The Hitchhiker's Guide to the Galaxy* (2005), O'Reilly signed with production company Colonel Blimp, where he has directed the music video for "Szamar Madar" by Venetian Snares, among other projects. He has also worked as a concept artist and designer for Studio AKA, on commercial projects for Italy's Fabrica, and on the 2007 feature *Son of Rambow* with Hammer & Tongs (a collaboration between film director Garth Jennings and producer Nick Goldsmith).

1–3. Stills from the short film *Serial Entoptics*.

1

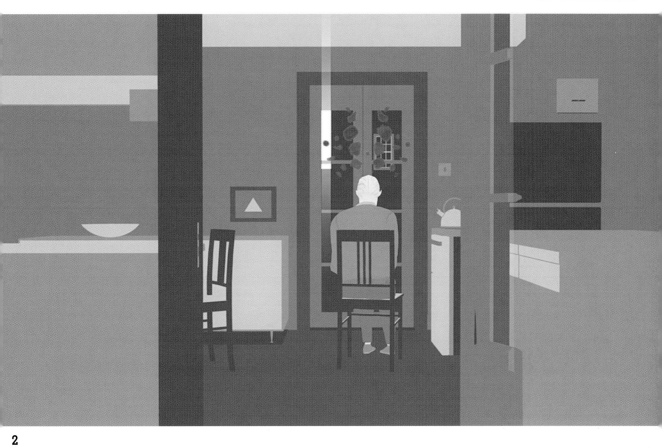

2

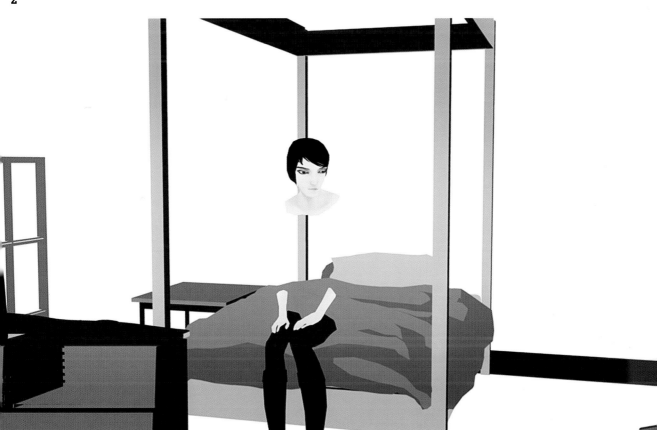

3

4

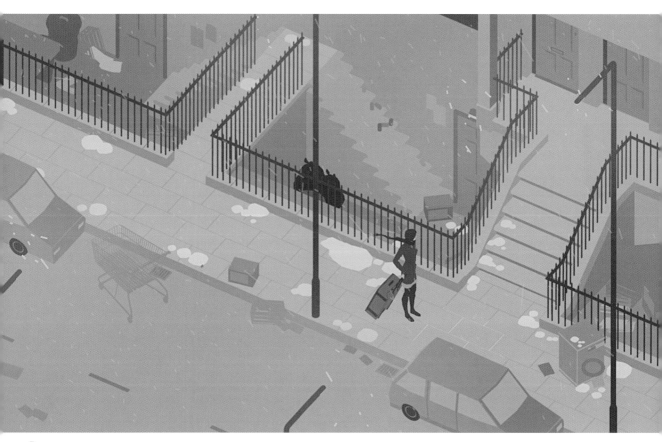

5

Punk method

O'Reilly's first independent short, *RGB XYZ* (2005), was part of the official selection at the 2008 Berlinale, and was selected for the 2008 Creative Futures scheme. This plotless, atmospheric 15-minute film is made of five sequences. His most recent film, *Serial Entoptics*, which had no storyboard and was inspired by a mood the artist wanted to convey, was created over the course of 11 months in 2007, and was first screened at the Pictoplasma Animation Festival in Berlin.

Of his singular creative process, he says, "It always starts with drawing—still the most effective way of capturing that elusive spark which sets the whole thing in motion. I like to think everything after is really just slave to the original drawings. Once you start working with software, the possibility for expressiveness eventually falls to zero."

In digital animation, O'Reilly believes it makes sense to use the same tools from project to project, because every time you reinvent the wheel you have to build everything from scratch. The advantage, he says, is that all 3D software is practically the same; there is, at present, no good reason to be using one over another.

"I like to stay involved at all stages of production," he says. "One has so much control with digital animation over classical … the only downside is that you get very sensitive about aesthetics; you become used to not compromising. When working with others, one becomes aware that there is a definite tendency to revert to old habits, perhaps to apply rules that were relevant in 2D animation. I think the more we can shake this off, the better. The only field in which I confess ignorance is sound and music. I'm happy to delegate that to the people who know it."

4–6. Stills from the short film *Serial Entoptics*.

All Images © 2008 David O'Reilly

Artist profile: Steven Subotnick

Country of origin: USA
Primary areas: Independent shorts
 (festivals and web)
Primary techniques: 2D, collage
URL: stevensubotnick.com

Steven Subotnick is an independent animator whose works explore the boundary between abstraction and narrative. His films have screened in many international film festivals, curated shows, museums, and galleries. In addition to his work as an independent animation artist, Subotnick has animated opera sets, worked on music videos, directed commercials, and designed interactive graphics. He has taught animation at Rhode Island School of Design; Harvard University; the School of the Museum of Fine Arts, Boston; Massachusetts College of Art and Design; and Wheaton College, Massachusetts.

1

3

2

His career as an independent animation film-maker began at California Institute of the Arts, where he studied with master artist Jules Engel. He made a number of short films (both abstract and narrative) utilizing a variety of under-the-camera performance techniques. These films received numerous screenings and awards, including second place in the ASIFA-East Animation Festival for *Snow Woman* and third place in the Nissan Focus Awards for *Dancing Bulrushes*.

1–4. Stills from *Glass Crow*.

4

Subotnick on creating *Glass Crow*

Glass Crow grew out of my reactions to reading about the Thirty Years' War, and specifically, the Defenestration of Prague in 1618. Firstly, I was fascinated that there is a word for throwing someone out a window. Secondly, I was amazed by the length and destructiveness of the war. And thirdly, I was disturbed by the mixture of religion and politics that made it such a confusing conflict. As a result, I became interested in baroque art, music, and literature, as well as history. I do a lot of research and reading. My inspirations for films come primarily from folklore, history, and religion. Perhaps I am interested in these because they are all the products of people finding or creating meaning out of otherwise chaotic events.

The crow is an observer of the war. It has no feelings about the conflict—it only eats, and reflects what it experiences. Because it flies, the crow moves between three levels—nature, humanity, and heaven. So the crow is a silent witness that moves the viewer through the landscape.

Basically, I would read about some detail or aspect of the war and then I would make artwork in response. For the most part, making artwork meant making a number of series of images and animated sequences. I used a variety of techniques: ink, paint, pencil, collage, and photographs. I scanned all the artwork into my computer and then began layering it in Adobe Photoshop and Adobe After Effects. After about a year of this, I began to edit sequences together. I had a rough idea that the crow would move through the landscape of Bohemia and witness the war. With this as my structuring idea, I put the film together.

After editing the picture, I began working on the soundtrack. I worked with music by two composers: Joan La Barbara and Alex Stolmack-Ness. Joan provided me with experimental vocals, and Alex composed a tarantella (a lively dance). I mixed these with sound effects. My goal was to create a soundtrack that mirrored the layered images in the film.

While researching baroque art, I came across an etching by Rembrandt called *The Three Trees*. Its composition is striking—a vast sky and a flat landscape connected only by the shapes of three trees. On closer inspection, many small human narratives can be seen—fishermen, wagon drivers, lovers, etc. This etching inspired two ideas. The first was that moving through a landscape can create a narrative, and this became the structure for my film. The second was that heaven and earth are two separate realms. This became the crow's point of view—objective and nonpartisan.

5

6

Of his experiences with Jules Engel he says, "Jules saw himself as a coach more than a teacher. He treated us as 'young talent' rather than students. His approach created a warm and supportive environment that encouraged experimentation, independence, and mutual respect. Working with Jules had a huge impact on me. It was under his guidance that I first came to see myself as a filmmaker."

After earning his MFA (Master of Fine Arts) in experimental animation from California Institute of the Arts (CalArts) in 1986, Subotnick moved to Providence to work at Rhode Island School of Design. That same year he was awarded an Individual Artist Fellowship in Film and Video by the Rhode Island State Council on the Arts, and in 1989 he received a Filmmaker's Grant from the American Film Institute. With this support, Subotnick produced *Calling Cards* (1992), *Devil's Book* (1994), and *Hairyman* (1998). Awards for these films include the Doug Haynes Award at the Onion City Film Festival for *Devil's Book* and Best Animation at the New England Film & Video Festival for *Hairyman*.

In 2003, Subotnick received a grant from the LEF Moving Image Fund and the Harvard Film Archive to produce *Glass Crow*, which garnered first place at the Black Maria Film & Video Festival, the Animation Award at the Flaherty Film Seminar, and the Shoestring Award at the Rochester International Film Festival. In January 2006, Subotnick worked at The MacDowell Colony (the oldest artists' colony in the US) on two films, and he later received a grant from the LEF Moving Image Fund to produce another project, *Lullaby*.

5–8. Stills from *Glass Crow*.

Images © 2008 Steven Subotnick

7

8

Artist profile: Emilio Ramos

||
Country of origin: Mexico
Primary areas: Independent
 shorts, advertising
Primary techniques: 3D, mixed media
URL: emilioramos.com

Niebla, a seven-minute short by Mexican animation director Emilio Ramos Fernández, was released in 2006. In it, an elderly man living in an impoverished village perpetually enshrouded in fog ("niebla" in Spanish) offers poetic reminiscences about the time the town was visited by an unexpected boon of sheep that arrived from the skies, briefly changing its fortunes.

Niebla began in 2005 as Ramos' Master's project in animation at Pompeu Fabra University in Barcelona, Spain, and was completed after one year and four months of work. Made by a small team from an original script, the film blends reality, imagination, and memory in a compelling way. It has been selected in more than 50 festivals around the world, and has received more than a dozen international awards.

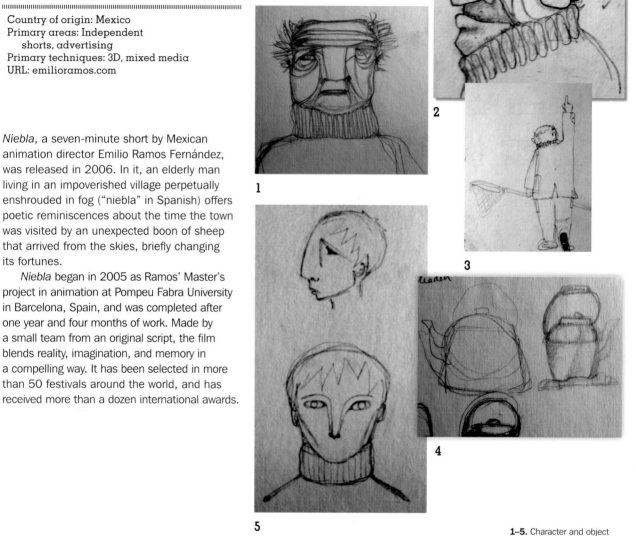

1–5. Character and object sketches. "We were not sure about the old man design," says Ramos. "It passed through several stages. Finally, we liked the one in profile (image 2). After that, we modeled the character in clay and made more changes. We tried to keep experimentation to the final stages of production to generate fresh results."

6

7

ALCALDE.

COREOGRAFIA. OFFENBACH

ES WICUL

8

6. Color palette for the dream section of *Niebla*. "There were two distinct environments in the story, each with its own sense of place and color: one for the old man's reality and one for his imagination. Here we show the color palette chosen for the old man's imagination, dreams, and memories, the half-washed colors in very old photographs, colors that evoke images from the past."

7 and 8. Storyboards from *Niebla*. "There was never a very well-drawn storyboard. I made it myself. But, as the team was very small and there were not many people that had to interpret it, this quality was good enough," says Ramos.

Prizes for *Niebla*

* Hiroshima International Animation Festival 2006 (Japan), Special Jury Prize
* Seoul International Cartoon and Animation Festival (SICAF) 2007 (South Korea), Special Distinction
* Virtuality Conference Student Competition (Italy), Special Jury Prize
* Festival Internacional de Cine de Guadalajara (Mexico), 1st Iberoamerican Animation Prize
* ArtFutura 2006 (Spain), Audience and 1st Jury Prize
* Animatu 2007 (Portugal), Grand Prize
* Animanima 2007 (Serbia), Grand Jury's Special Mention
* Barcelona VisualSound (Spain), 1st Animation Prize
* Boulder International Film Festival (USA), Best Animated Film
* SICARM (Sociedad de la Información, Región de Murcia) 2006 (Spain), Accesit Prize
* Festival El Cine a las Calles (Mexico), 1st Animation Prize
* Festival Internacional de Curtmetratges Mas Sorrer (Spain), Best Catalan Short Film
* I Castelli Animati 2007 (Italy), Best First Film
* SIGGRAPH 2006 (USA), Official Selection
* Annecy International Animation Festival 2007 (France), Official Selection
* Animafest 2008 Zagreb (Croatia), Official Selection

9–11. More storyboards from *Niebla*.

9

10

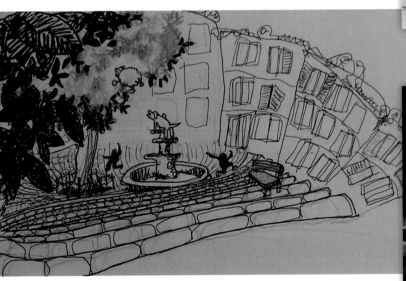

11

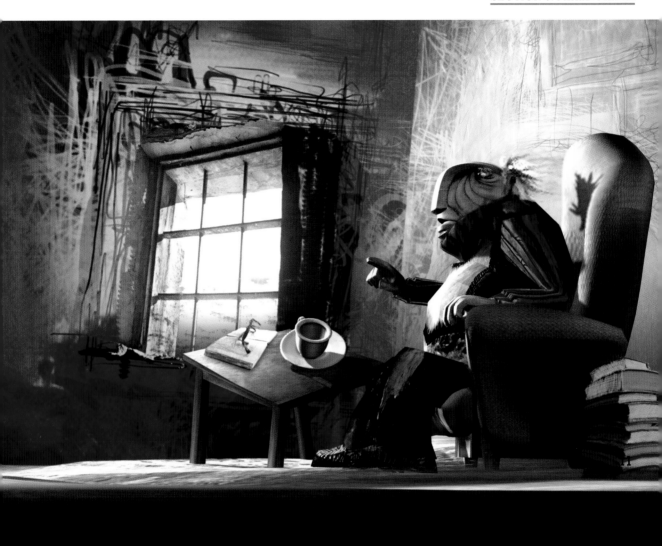

12

Ramos, born in Mexico City in 1972, has worked in the animation field since 1995, mostly on advertising and cultural projects for Gretel Studio Animation and Malpaso postproduction house, among other clients. From 2006 to 2007 he animated for and coordinated the team that produced the 3D animated scenery for the Wagner opera *The Ring of the Nibelung*, produced in two parts, both by the highly praised Catalan theatrical company La Fura dels Baus, and presented at the City of Arts and Sciences in Valencia, Spain.

12. Still from *Niebla*.

13

14

Cast and crew

* **Direction:**
 Emilio Ramos
* **Animation/Design/Illustration:**
 Emilio Ramos
 María del Mar Hernández
 Jordi Codina
* **Music:**
 Leo Heiblum
* **Script:**
 María del Mar Hernández
 Jordi Codina
 Emilio Ramos
* **Old man's voice:**
 Josep Codina
* **Render:**
 Irakli Kublashvili
* **Still photography:**
 Rocío Ramos
 Santiago Garcés
* **Credits design:**
 Diana López Font
* **Production:**
 Producciones Atotonilco, Mexico City
 Pompeu Fabra University, Master in
 Animation, Barcelona

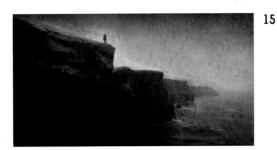

15

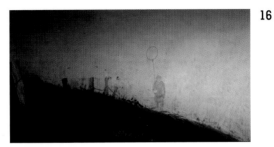

16

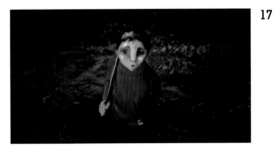

17

13–18. Stills from *Niebla*.

18

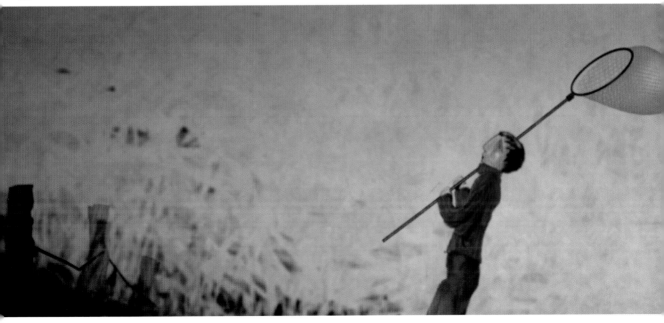

19

19–40. Stills from *Niebla*.

All images © 2008 Emilio Ramos Fernández

Preserving memory

As in Gabriel García Márquez's magic-realist novel *One Hundred Years of Solitude*, *Niebla*'s precise setting is uncertain—somewhere in rural Latin America—and the story's narrator is El Pep, an old man being interviewed in his living room by a documentary film crew about the mysterious fog of the title and the resulting visitation by a strange flock of flying sheep.

"I dreamed the last sequence; it was a nightmare," says Ramos. "I was being chased by a cloud of evil sheep. I ran away, but they reached me. I dreamed all this with an opera soundtrack in the background that made the moment even more dramatic. I used my nightmare to tell a sad and nice moment."

Ramos based the character of the old man on his grandmother. "She was a very complex person, with many frustrations in life," he says.

"She was born during the Mexican Revolution, so she experienced a lack of material possessions all her life. But she was also very kind and loving with her family. She had a combination of marked strengths and weaknesses. At the end of her life she suffered from dementia. 'My mind is leaving me,' she used to say, distressed, when she noticed. The only moments we could communicate with her were when we asked her about her past life. Those memories were the last to vanish."

Ramos and his team animated the 3D characters mostly using Autodesk Maya, while also incorporating a range of other techniques: photography; traditional illustration in watercolor, pastel, and ink; digital illustration using Adobe Photoshop; 2D digital animation; and also some video details. The backgrounds were all 2D flats drawn by hand on a Wacom Tablet.

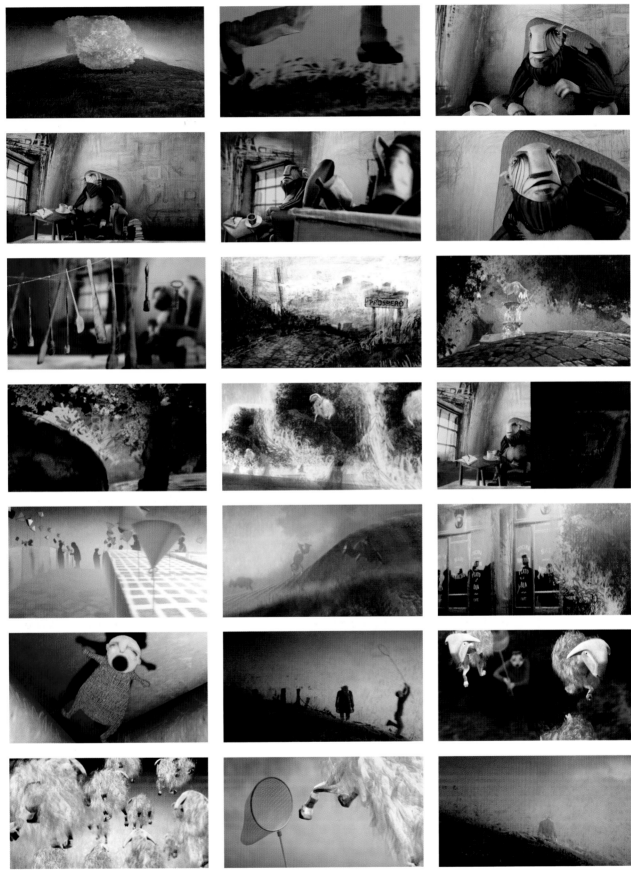

20–40

Case study: Making *Mechanical Figures*

An international team of filmmakers led by Croatian animator, director, and producer Helena Bulaja (bulaja.com) is taking digital animation fully into the realm of multimedia. The team's interactive project, *Mechanical Figures – twentythousandcycles.NET,* is about sources and uses of creativity, inspired by the scientist and inventor Nikola Tesla. They call it a "movie project" rather than simply a "movie" because of the complexity of the final outputs.

"When we say that the project is inspired by Tesla," says Bulaja, "we mean that it is not a documentary, but a story about an obsessed filmmaker who is trying to make a movie about Tesla, using Tesla as a muse to tell a story about creativity. As part of that journey, we collected thoughts about Tesla and creativity from other artists inspired by Tesla, and who also inspired our own work."

1

2

3

4

5

The team began work on the project, which was sponsored by the Ministry of Culture of the Republic of Croatia and the Zagreb City Council for Culture, in the summer of 2004, and the project was released to the public in 2009. The project consists of four complementary parts: a website, a film, a performance, and a collection of 16 art books.

6

The basic working method for the project is similar to that used for Bulaja's previous award-winning, two-part Flash animation project, *Croatian Tales of Long Ago* (2002 and 2006), with international artists collaborating in person and through the Internet.

"The main idea of the Tesla project is to try to reconstruct the creative process in the mind of a genius, through a chain of 16 interactive multimedia stories inspired by Tesla and his life and work in New York City and Colorado Springs," says Bulaja. "The stories will be interconnected through the exploration of two real and two imaginary female characters who are trying to reconstruct the labyrinthine path of creativity that occurs en route from idea to final outcome."

7

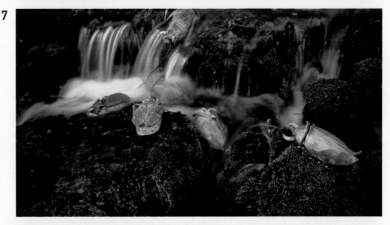

8

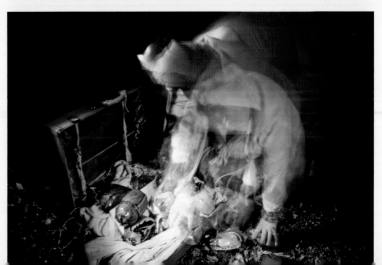

1–8. Stills from *Mechanical Figures*. According to Helena Bulaja, Nikola Tesla made his first turbine, while still a child, by gluing beetles to sticks. His idea was that the movement of the beetles' wings would move the little stick propeller that, in turn, would move the entire mechanism. The team used that idea to create 16 ceramic June bugs that become the main characters of the film. The creative team used traditional stop-motion animation techniques (without digital editing) to create the illusion of movement. The photographs were color-processed in Photoshop Lightroom, assembled in iStopMotion, compressed in Compressor, and put together in Final Cut Pro.

9

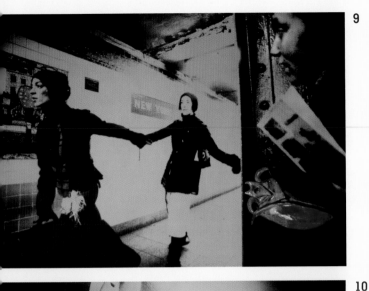

The website

According to Bulaja, the website is organized as an imaginative warehouse of ideas, links, and facts "with the potential to open countless avenues for interpretation, and with links to other pages allowing for the possibility of multiple and open endings." The site (twentythousandcycles. net) she says, will try to push the visitor to further explore Tesla's life and work and to recreate the chain of association that occurs in scientific thinking and any other form of creation.

The film

A combination of documentary and animation, the film includes 16 stories that are triggered by filmed interviews with artists and creative people whom Tesla inspired: experimental musician Laurie Anderson, performance artist Marina Abramovic, cyber-culture theoretician Douglas Rushkoff, novelist Christopher Priest, director Terry Gilliam, actor Andy Serkis, and many others.

The film is intended for a range of viewing experiences, including theatrical and broadcast screenings in high-definition (HD) format. It also serves as the core movie for an interactive piece that will be composed from a collection of short video clips, and created for interactive viewing on mobile devices and the Internet.

10

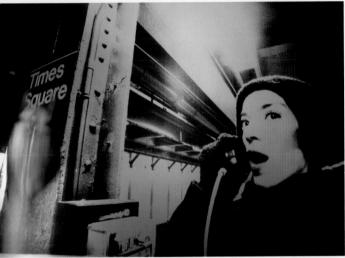

9–11. More stills from *Mechanical Figures*.

12–19. Stop-motion stills from *Mechanical Figures* incorporating photographs of interview subjects and New York City scenes, staged on an old radio named Tesla that was manufactured by a Czech company. Pictured are Christopher Priest (12), Laurie Anderson (14), Marina Abramovic (16), and Terry Gilliam (18).

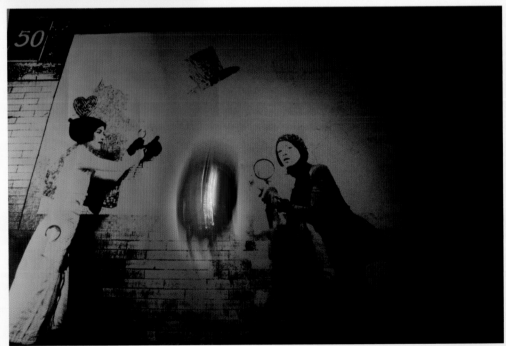

11

13

15

17

19

Project team

* **Helena Bulaja (Croatia):** project author, writer, main director, producer
* **Zvonimir Bulaja (Croatia):** executive producer, cowriter, programmer
* **Alistair Keddie (Scotland):** codirector, photographer, editor, animator
* **Edgar Beals (Canada):** codirector, cinematographer, photographer, animator
* **Christian Biegai (Germany):** codirector, composer, sound designer
* **Mare Milin (Croatia):** photographer
* **Blaž Habuš (Croatia):** animator, editor, sound designer
* **Joshua Sternlicht (USA):** cinematographer
* **Stuart Page (New Zealand):** cinematographer, editor
* **Sabina Hahn (USA):** animator, sculptor, designer, performer
* **Petar Grimani (Croatia):** performer
* **Boris Cvjetanovi (Croatia):** photographer
* **Josipa and Marijana Broni (Croatia):** costume designers, performers

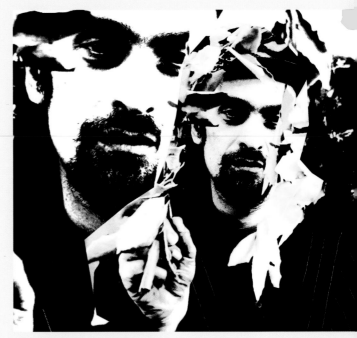

20

20–27. Digital video composites from *Mechanical Figures*.

21

22

Says Bulaja, "The process of creating a story about creativity has allowed us to explore our creative potential, to play, to learn new techniques, and finally to create one truly interactive, visually distinctive, adventurous experience for small screens and mobile devices." The team used a combination of several animation techniques: digital compositing of computer-generated 2D and 3D animation, digital video and film footage, traditional and digital photography, and nondigital animation techniques such as stop-motion, pixilation, and drawn frame-by-frame animation.

26

23

24

27

25

Software used includes Apple's Final Cut Studio, with extensive use of its Motion application; Photoshop, Flash, Photoshop Lightroom, After Effects, and Illustrator (all from Adobe); and iStopMotion, SketchUp, and Bryce.

The filming began in January 2006 in New York City and Colorado Springs, USA, and continued in Croatia, Hungary, Serbia, the UK, and New Zealand. "By showing the locations where Tesla lived and worked," Bulaja says, "the film will be a sort of time and space adventure with imaginary host characters. By exploring the urban and social development of the city in Tesla's lifetime they will find the places that link the city with Nikola Tesla by recovering his inventions, thoughts, and social activities which directly influenced the formation of the world we know today."

28

29

The performance

This part of the project includes reinterpreting and recreating the materials made for web and film on the real space of the stage. "We have tried to evoke the atmosphere of Tesla's lab, where time has stopped, and the space is filled with the magic of his visionary inventions," says Bulaja.

"We all hope that the project will inspire people around the globe to experiment and create their own stories, their own animated films," she concludes.

28–30. 3D spaces that serve as environments for hand-drawn and cut-paper characters in *Mechanical Figures*.

All Images © 2008 Helena Bulaja

Who's Tesla?

Nikola Tesla (1856–1943) is regarded as one of the most important physicists and inventors in history. He is well known for his contributions to the study of electricity and magnetism. His patents and theoretical work form the basis of modern alternating current (AC) electric power systems, radio, and wireless technologies. His inventions helped to usher in the Second Industrial Revolution. Tesla is widely known for his rivalry with the inventor Thomas Alva Edison, who advocated direct current (DC) for electricity (Tesla's AC system prevailed); and with Guglielmo Marconi over the invention of radio transmission. He was also a well-known personality of his time and a close friend of many artists, including Mark Twain and Sarah Bernhardt. Tesla was born in Smiljan, near Gospi, in central Croatia, but spent most of his life in New York City. By ancestry he was Serbian, the son of an orthodox priest. He inspired the work of innumerable artists including Jim Jarmusch, Paul Auster, Keith Sonnier, Paul Laffoley, David Bowie, and many more.

30

6 Additional Resources

Reference guide

Recommended reading

General

3D Toons
Steve Anzovin and Raf Anzovin
(Barron's Educational Series, 2005)

Animation Art
Jerry Beck
(HarperCollins, 2004)

The Animation Business Handbook
Karen Raugust
(St. Martin's Press, 2004)

Animation Magazine (periodical)

The Art of Game Characters
Leo Hartas
(HarperCollins, 2005)

The Art of Game Worlds
Dave Morris and Leo Hartas
(HarperCollins, 2004)

The Art of Ratatouille
Karen Paik
(Chronicle Books, 2007)

The Art of Robots
Amid Amidi and William Joyce
(Chronicle Books, 2005)

The Art of Watching Films
Joseph M. Boggs and Dennis W. Petrie
(McGraw Hill College, 2006)

Character Design for Graphic Novels
Steven Withrow and Alexander Danner
(RotoVision, 2007)

Creating 3-D Animation
Peter Lord and Brian Sibley
(Harry N. Abrams, 1998)

Dream Worlds
Hans Bacher
(Focal Press, 2007)

Dynamic Anatomy
Burne Hogarth
(Watson-Guptill, 2003)

*Force: Dynamic Life Drawing
for Animators*
Mike Mattesi
(Focal Press, 2006)

The Fundamentals of Animation
Paul Wells
(Watson-Guptill, 2006)

Game Design Workshop
Tracy Fullerton
(Focal Press, 2008)

How to Draw and Sell Digital Cartoons
Leo Hartas
(Barron's Educational Series, 2004)

Human Anatomy for Artists
Eliot Goldfinger
(Oxford University Press, 1991)

The Human Figure in Motion
Eadweard Muybridge
(Dover Publications, 1955)

The Illusion of Life: Disney Animation
Ollie Johnston and Frank Thomas
(Disney Editions, 1995)

*The Invisible Art: The Legends
of Movie Matte Painting*
Mark Cotta Vaz and Craig Barron
(Chronicle Books, 2002)

Nigel Holmes on Information Design
Steven Heller
(Jorge Pinto Books, 2006)

Outlaw Animation
Jerry Beck
(Harry N. Abrams, 2003)

Toon Art
Steven Withrow
(Watson-Guptill, 2003)

Understanding Animation
Paul Wells
(Taylor & Francis, 1998)

Vector Graphics and Illustration
Jack Harris and Steven Withrow
(RotoVision, 2008)

Webcomics
Steven Withrow and John Barber
(Barron's Educational, 2005)

Your Career in Animation
David B. Levy
(Allworth Press, 2006)

History

Before the Animation Begins
John Canemaker
(Hyperion, 1996)

*Cartoon Modern: Style and Design
in Fifties Animation*
Amid Amidi
(Chronicle Books, 2006)

Disney Lost and Found
Charles Solomon
(Disney Editions, 2008)

*Droidmaker: George Lucas and
the Digital Revolution*
Michael Rubin
(Triad Publishing, 2005)

*Enchanted Drawings: The History
of Animation*
Charles Solomon
(Knopf, 1989)

*Paper Dreams: The Art and Artists
of Disney Storyboards*
John Canemaker
(Hyperion, 1999)

The Pixar Touch
David A. Price
(Knopf, 2008)

Rogue Leaders: The Story of LucasArts
Rob Smith
(Chronicle Books, 2008)

*To Infinity and Beyond!: The Story
of Pixar Animation Studios*
Karen Paik
(Chronicle Books, 2007)

*Walt Disney's Nine Old Men and
the Art of Animation*
John Canemaker
(Disney Editions, 2001)

Winsor McCay: His Life and Art
John Canemaker
(Abbeville Press, 1987)

Technique

Adobe Flash CS3 Professional Bible
Robert Reinhardt and Snow Dowd
(Wiley, 2007)

Advanced Maya Texturing and Lighting
Lee Lanier
(Sybex, 2008)

The Alchemy of Animation
Don Hahn
(Disney Press, 2008)

The Animation Book
Kit Laybourne
(Crown Publishing, 1998)

Animation from Pencils to Pixels
Tony White
(Focal Press, 2006)

The Animator's Survival Kit
Richard Williams
(Faber and Faber, 2002)

The Animator's Workbook
Tony White
(Watson-Guptill, 1988)

*The Art of 3D Computer Animation
and Effects*
Isaac Victor Kerlow
(Wiley, 2003)

The Art of Machinima
Paul Marino
(Paraglyph Press, 2004)

Cartoon Animation
Preston Blair
(Walter Foster, 1994)

Character Animation Crash Course!
Eric Goldberg
(Silman-James Press, 2008)

Cinematography
Peter Ettedgui
(Focal Press, 1999)

Digital Lighting and Rendering
Jeremy Birn
(New Riders Press, 2000)

Digital Texturing and Painting
Owen Demers
(New Riders Press, 2001)

The Essential Blender
Roland Hess
(No Starch Press, 2007)

Flash 3D
Jim Ver Hague and Chris Jackson
(Focal Press, 2006)

*Gardner's Guide to Creating 2D
Animation in a Small Studio*
Bill Davis
(Garth Gardner Company, 2006)

How to Cheat in Adobe Flash CS3
Chris Georgenes
(Focal Press, 2007)

How to Wow with Flash
Colin Smith
(Peachpit Press, 2006)

Inspired 3D Short Film Production
Jeremy Cantor and Pepe Valencia
(Course Technology, 2004)

*Introducing Character Animation
with Blender*
Tony Mullen
(Sybex, 2007)

Machinima
Dave Morris, Dave Lloyd,
and Matt Kelland
(Cengage Learning, 2005)

Machinima for Dummies
Hugh Hancock and Johnnie Ingram
(John Wiley & Sons, 2007)

Maya Professional Tips and Techniques
Lee Lanier
(Sybex, 2007)

Maya Visual Effects
Eric Keller
(Sybex, 2007)

Producing Animation
Catherine Winder and Zahra Dowlatabadi
(Focal Press, 2001)

*Stop Staring: Facial Modeling and
Animation Done Right*
Jason Osipa
(Sybex, 2007)

Thinking Animation
Angie Jones and Jamie Oliff
(Course Technology, 2006)

Timing for Animation
Harold Whitaker and John Halas
(Focal Press, 2002)

Writing

The Anatomy of Story
John Truby
(Farrar, Straus, and Giroux, 2007)

Animation from Script to Screen
Shamus Culhane
(St. Martin's Press, reprint, 1990)

Animation Writing and Development
Jean Ann Wright
(Focal Press, 2005)

*Gardner's Guide to Feature
Animation Writing*
Marilyn Webber
(Garth Gardner Company, 2003)

How to Write for Animation
Jeffrey Scott
(Penguin Group, 2003)

Prepare to Board!
Nancy Beiman
(Focal Press, 2007)

Screenplay by Disney
Jason Surrell
(Disney Press, 2004)

*Story: Substance, Structure, Style, and
The Principles of Screenwriting*
Robert McKee
(HarperCollins, 1997)

*Writing for Animation, Comics,
and Games*
Christy Marx
(Focal Press, 2006)

Web resources

Academy of Machinima Arts
and Sciences
machinima.org

ActionScript.org (Flash)
actionscript.org

Anima Mundi International
Animation Festival (Brazil)
animamundi.com.br

Animation Backgrounds (blog)
animationbackgrounds.blogspot.com

Animation Guild (blog)
animationguildblog.blogspot.com

Animation Magazine
animationmagazine.net

Animation Mentor
animationmentor.com

Animation Podcast
animationpodcast.com

Animation Show
animationshow.com

Animation World Network
awn.com

Annecy International Animated
Film Festival (France)
annecy.org

ASIFA (International Animated
Film Association)
asifa.net

ASIFA-Hollywood Animation Archive
animationarchive.com

AtomFilms
atomfilms.com/films/flash_cartoons.jsp

Carlos Baena (Pixar animator/
co-founder of Animation Mentor)
carlosbaena.com

Cartoon Brew (news related
to animation)
cartoonbrew.com

cgchar-animation (forums)
cgchar-animation.com

CG Society (forums)
cgtalk.com; forums.cgsociety.org

Cold Hard Flash
coldhardflash.com

Dave K's Poly Head Modeling Tutorial
thehobbitguy.com/tutorials/
polymodeling/index.html

Drawn! (blog)
drawn.ca

fps: frames per second magazine
fpsmagazine.com

Hans Perk (blog, Denmark)
afilmla.blogspot.com

Hydrocephalic Bunny (blog)
hydrocephalicbunny.blogspot.com

International Animation Festival
Hiroshima (Japan)
hiroanim.org

I Want My Flash TV
iwantmyflashtv.com

Jason Ryan (tutorials)
jasonryananimation.com

Jerry Beck's Cartoon Research
cartoonresearch.com

John Kricfalusi
johnkstuff.blogspot.com

Keith Lango (great free tutorials)
keithlango.com

Kevin Koch
synchrolux.com

lines and colors (blog)
linesandcolors.com

Machinima.com
machinima.com

Machinima for Dummies
machinimafordummies.com

Mark Evanier (blog)
newsfromme.com

Mark Kennedy (blog)
sevencamels.blogspot.com

Mark Mayerson (blog)
mayersonanimation.blogspot.com

Meathaus
meathaus.com

Michael Barrier
michaelbarrier.com

Motion Design (blog)
motiondesign.wordpress.com

Motionographer (blog)
motionographer.com

No Fat Clips!!! (blog)
dekku.blogspot.com

Ottawa International Animation
Festival (Canada)
ottawa.awn.com

Patrick Smith (blog)
blendfilmsinc.blogspot.com

Sessions Online School of Design
sessions.edu

SIGGRAPH (US conference)
siggraph.org

Spline Doctors (run by Pixar animators)
splinedoctors.com

Strut Your Reel
strutyourreel.com

Tennessee Reid Norton (blog)
ananimatedmind.blogspot.com

Twitch Film
twitchfilm.net

Victor Navone (Pixar animator)
navone.org/blogger

Ward Jenkins (blog)
wardomatic.blogspot.com

Will Finn (blog)
willfinn.blogspot.com

Contributor links

Anzovin, Raf (USA)
anzovin.com

Balistreri, Ben (USA)
benbalistreri.blogspot.com

Big Buck Bunny (international)
bigbuckbunny.org

Bizanski, Adam (Israel)
adambizanski.com

Blender Institute (the Netherlands)
blenderinstitute.nl

Bulaja, Helena (Croatia)
bulaja.com

del Rio, Julio (Spain/UK)
juliodelrio.com

Deneroff, Harvey (USA)
deneroff.com

Dixit, Gayatri (India)
gayatridixit.com

Feinberg, Xeth (USA)
mishmashmedia.com

Feldman, Luke (Australia)
skaffs.com

Georgenes, Chris (USA)
mudbubble.com; sessions.edu

Goobees (USA)
goobeesFilm.com

Gutierrez, Paul (USA)
gotgutz.com

Holmes, Nigel (UK/USA)
nigelholmes.com

Ibele, Tyson (Canada/New Zealand)
tysonibele.com

ILL Clan Animation Studios (USA)
illclan.com

Knapp, Michael (USA)
michaelknapp.com; outofpicture.com

Kulavoor, Sameer (India)
sameerkulavoor.com

Levy, David B. (USA)
animondays.blogspot.com

Marx, Christy (USA)
christymarx.com

Matreyek, Miwa (USA)
semihemisphere.com; cloudeyecontrol.
com

Mechanical Figures (international)
twentythousandcycles.net

Myers, Chris (USA)
chrismyers3d.com

O'Reilly, David (Ireland/Germany)
davidoreilly.com

Paley, Nina (USA)
ninapaley.com; sitasingstheblues.com

Prado, Cassiano (Brazil/UK)
cassiano.tv

Rainsberger, Melinda (USA)
melindathemartian.com

Ramos, Emilio (Mexico)
emilioramos.com

Sava, Scott Christian (USA)
bluedreamstudios.com;
thedreamlandchronicles.com

Scott, Jeffrey (USA)
jeffreyscott.tv

Sias, Ryan (USA)
ryansias.com

Sporn, Michael (USA)
michaelspornanimation.com

Stuhmiller, Rigel (USA)
drenculture.com

Subotnick, Steven (USA)
stevensubotnick.com

Tierney, Adam (USA)
adamtierney.com

van der Merwe, JD (South Africa/UK)
aserash.com

Vasconcelos, Virgilio (Brazil)
virgiliovasconcelos.com

Wallin, Michael J. (USA)
michaeljwallin.com

Wong, Henri (Hong Kong)
parabucks.com

Zubkavich, Jim (Canada)
makeshiftmiracle.com; zubkavich.
livejournal.com

Glossary

2D
Two-dimensional images or images not created with 3D software or other 3D techniques. Often refers to classic drawn or cel animation.

3D
Three-dimensional images or animation, created with computer software; also, any animation created using real-world objects with true dimensionality, such as dolls, brick blocks, clay, and so on.

animatic
A "planning" movie for an animation; an aid to visualization of shot layout, camera angles/moves, and blocking of basic character moves. Created with scanned drawings, toys, video, or simple 3D models, and edited together to establish pacing and continuity.

animation
Moving graphics. Created by quickly displaying a succession of related images, called frames, so that the brain blends them together into a continuous sequence (persistence of vision).

anime
Japanese cartoon animation, with idiosyncratic stylistic conventions widely emulated in world animated cinema.

avatar
A computer representation of a user or game player.

bitmap
Resolution-dependent image defined as a grid of differently colored pixels.

cartoon
1) Any graphic work that employs stylization, economy of design, exaggeration, and caricature.
2) A humorous, character-based animation with a simplified graphic style and frenetic, exaggerated motion and pacing.

cel
Animation celluloid. Each cel is a frame in an animation; a transparent sheet on which an image is drawn or painted.

CG
Computer graphics. Shorthand for the use of 3D in TV and cinema.

color timing
Altering or enhancing the color continuity of a moving image.

compositing
3D postproduction process of layering images or animations to create a final work of many combined elements.

cutscene
Animated cinematic sequence inserted into a video game, often to set up the game premise, or to introduce new levels and new characters.

feature
A full-length motion picture, usually at least 80 minutes long. Animated features are traditionally somewhat shorter than live-action features.

filmout
Transferring images from videotape or digitial files to celluloid.

frame
A single image from a motion picture. There may be more than 100,000 frames in an animated feature.

frames per second
The rate that frames are played in an animation. The standard feature-film frame rate is 24 frames per second.

game engine
Software development kit for creating video games. Some game engines contain character-animation tools that can be adopted to make automated or script-driven, noninteractive movies called machinima.

geometry
The "skin" of a model, made of polygons or splines, before rigging and texturing. Also called mesh.

global illumination
A rendering approach in which the light bouncing among all objects in a scene is calculated. Provides high realism at high cost in computation.

information graphics
Also called infographics or explanation graphics. Visual explanations of numbers, geography, events, and processes—in short, any data or knowledge—that help readers/users to understand an often complex subject.

keyframe
Frame that defines the beginning, ending, or important pose of a character motion or object animation sequence.

layout
Stage of 3D animation production in which character motion and camera moves are roughed out before finished animation is added.

machinima
Movie animation created using a game engine.

map, mapping
1) Image applied to the surface of a 3D model. 2) The process of applying such maps. Maps can apply photograph-like textures, and also control bumpiness, specularity, color, surface displacement, and other surface characteristics.

model
3D object built from polygons or splines.

model sheet
Design document specifying the look and characteristic poses of a character.

motion capture
Recording live movement and translating it onto a digital model.

motion graphics
Graphics using video and/or animation to create the illusion of motion or transformation. Refers to graphics for television and film.

motion tween
In Adobe Flash, the interpolation of an object's properties between two or more keyframes with frames between them. Properties include position, scale, filters, and alpha and color effects.

pencil test
A preliminary version of the final animated scene.

pipeline
The sequential production process of an animated film. In most cases, this means the channeling of animation assets through the main stages of production.

polygon
A patch, often triangular, used to define the surface of a 3D model.

pose
A key position of a character.

procedural animation
Type of computer animation used to automatically generate animation in real time to allow for a more diverse series of actions than could otherwise be created using predefined animations.

render
To create a 2D representation of a 3D scene.

render farm
A system of networked computers, often incorporating thousands, used exclusively to render frames for animation.

rigging
The process of adding bones, controls, and constraints to a 3D character or other articulated model to prepare it for animation. Also called setup.

shader
A procedural (algorithmic) texture for models, ready-made or written in a shader programming language.

shape tween
In Adobe Flash, shape tweens are applied to raw vector shapes and interpolate between two different shapes in two different keyframes.

short
A brief independent animation, usually less than 10 minutes long.

skeleton
The underlying bone structure of a 3D character.

spline
A curve used to define the shape of a model.

spot
A television commercial.

stop-motion
Form of animation in which real-world objects are moved incrementally, with each incremental move recorded to a single frame of video or film.

storyboard
Graphic organizer such as a series of illustrations or images displayed in sequence for the purpose of previsualizing a motion graphic or interactive media sequence.

texture
Surface characteristics of a 3D model. May be composed of many layers.

timeline
Tool in Adobe Flash used to create layers, and to insert frames and keyframes that control the timing of an animation.

UV
A point on a polygon used by Autodesk Maya to map a texture onto the polygon.

vector
Resolution-independent graphic file composed of line and curve segments.

walk cycle
A sequence of frames representing a (usually human) walk movement. Important because, when a walking person appears in an animation, the walk cycle can simply be looped over and over, without having to animate each step again.

wireframe
Representation of a 3D model as unshaded polygons or splines. A good way to view the model's structural details.

Author note: Special thanks to Raf Anzovin (anzovin.com) and his late father Steve Anzovin for providing certain definitions. Their book *3D Toons: Creative 3D Design for Cartoonists and Animators* (Barron's Educational Series, 2005) is highly recommended.

Index

Acknowledgments

Thanks to all the animators, directors, and other artists who contributed their thoughts, images, and time to this project—especially Chris Georgenes, Patrick O'Brien, Tony Piedra, Chris Myers, Tyson Ibele, JD van der Merwe, Frank Dellario, Michael J. Wallin, and Raf Anzovin (and his father, the late Steve Anzovin). You are all my inspiration. To everyone at RotoVision and Rockport. And to Lesley and Marin, for absolutely everything.

Picture credits

Covers and flaps

Front cover: © Michael Knapp, © Blender Foundation, www.bigbuckbunny.org, and licensed under the Creative Commons Attribution 3.0, © Helena Bulaja, © Seth Freeman, Michael Losure, Patrick O'Brien, and P. Antonio Piedra, © Adam Bizanski, © Miwa Matreyek, © Emilio Ramos Fernández. **Back cover:** © Dado Ramadani, © Nina Paley, © Seth Freeman, Michael Losure, Patrick O'Brien, and P. Antonio Piedra, © Michael Knapp, © Steven Withrow and Paul Gutierrez. **Flaps:** © Miwa Matreyek, © JD van der Merwe, © Dado Ramadani, © ILL Clan Animation Studios, © Julio del Rio Hernandez, © Devin M. Ruddick, © Michael Sporn Animation, Inc.

Introduction

Page 1: © Cassiano Prado. **Pages 2 and 3:** © Helena Bulaja, © Michael Knapp, © Julio del Rio Hernandez, © ILL Clan Animation Studios, © Luke Feldman. **Pages 4 and 5:** © Ty Varszegi, © Luke Feldman, © Gayatri Dixit and Sameer Kulavoor, © Michael J. Wallin. **Pages 6 and 7:** © Steven Yeun and Henri Wong, © Emperor Multimedia Group (EMG) [hk].

Section 1

Pages 8 and 9: © Michael Knapp, © Rigel Stuhmiller, © Ty Varszegi, © Gayatri Dixit and Sameer Kulavoor, © Steven Withrow and Paul Gutierrez, © Blender Foundation, www.bigbuckbunny.org, and licensed under the Creative Commons Attribution 3.0, © Nigel Holmes and Rowland Holmes. **Pages 10 and 11:** © Ty Varszegi, © Ryan Sias, © Devin M. Ruddick. **Pages 12 and 13:** © Gayatri Dixit and Sameer Kulavoor. **Pages 14 and 15:** © Steven Withrow and Paul Gutierrez. **Pages 16 and 17:** © Rigel Stuhmiller. **Pages 18–23:** © Ben Balistreri. **Pages 24 and 25:** © Nigel Holmes and Rowland Holmes. **Pages 26–29:** © Blender Foundation, www.bigbuckbunny.org, and licensed under the Creative Commons Attribution 3.0. **Pages 30–33:** © Nina Paley. **Pages 34–37:** © Cassiano Prado. **Pages 38–43:** © Michael Knapp.

Section 2

Pages 44 and 45: © Ben Balistreri, © David B. Levy, © Michael Sporn Animation, Inc., © Chris Georgenes, © Luke Feldman. **Pages 46 and 47:** © Michael Sporn Animation, Inc. **Pages 48–55:** © Chris Georgenes. **Pages 56 and 57:** © David B. Levy. **Pages 58–61:** © Luke Feldman.

Section 3

Pages 62 and 63: © Chris Myers and Ken Seward, © Dado Ramadani, © Tyson Ibele, © Julio del Rio Hernandez, © Seth Freeman, Michael Losure, Patrick O'Brien, and P. Antonio Piedra. **Pages 64 and 65:** © Dado Ramadani. **Pages 66–75:** © Seth Freeman, Michael Losure, Patrick O'Brien, and P. Antonio Piedra. **Pages 76–83:** © Chris Myers and Ken Seward. **Pages 84–93:** © Tyson Ibele. **Pages 94–99:** © JD van der Merwe. **Pages 100–103:** © Julio del Rio Hernandez. **Pages 104–107:** © Virgilio Vasconcelos.

Section 4

Pages 108 and 109: © Michael J. Wallin, © Adam Bizanski, © Miwa Matreyek, © Adam Tierney. **Pages 110–115:** © ILL Clan Animation Studios. **Pages 116–119:** © Adam Tierney. **Pages 120–129:** © Michael J. Wallin.

Section 5

Pages 130 and 131: © David O'Reilly, © Emilio Ramos Fernández, © Steven Subotnick. **Pages 132–135:** © Adam Bizanski. **Pages 136–139:** © Miwa Matreyek. **Pages 140–143:** © David O'Reilly. **Pages 144–147:** © Steven Subotnick. **Pages 148–155:** © Emilio Ramos Fernández. **Pages 156–163:** © Helena Bulaja.

Section 6

Pages 164 and 165: © Helena Bulaja, © Steven Subotnick, © David O'Reilly, © Michael J. Wallin, © Chris Myers and Ken Seward. **Page 169:** © Luke Feldman. **Page 172:** © Julio del Rio Hernandez.